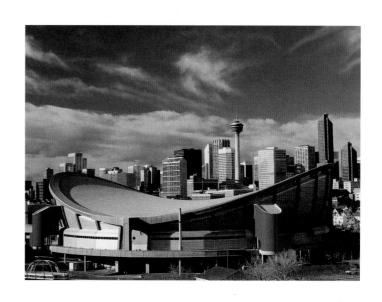

CALGARY

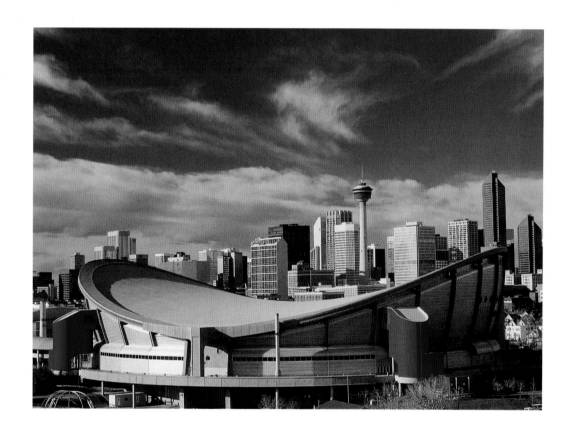

WHITECAP BOOKS
VANCOUVER / TORONTO / NEW YORK

Text by Tanya Lloyd
Edited by Elaine Jones
Photo editing by Tanya Lloyd
Proofread by Lisa Collins
Cover and interior design by Steve Penner
Desktop publishing by Graham Sheard
Printed and bound in Canada

Canadian Cataloguing in Publication Data

Lloyd, Tanya, 1973–

 Calgary

 ISBN 1-55285-018-8

 1. Calgary (Alta.) — Pictorial works. I. Title.
FC3697.37.L56 2000 971.23'3803'0222 C00-910057-1
F1079.5.C35L56 2000

The publisher acknowledges the support of the Canada Council and the Cultural
Services Branch of the Government of British Columbia in making this publication
possible. We acknowledge the financial support of the Government of Canada through
the Book Publishing Industry Development Program for our publishing activities.

**For more information on the Canada Series and other Whitecap Books
titles, please visit our web site at www.whitecap.ca.**

Competitors in the North American Saddle Bronc Riding Championship have about eight seconds to prove their worth. They must spur their bucking mounts, keep their heels in the stirrups, and maintain a tight grip on the halter—with one hand. Contestants are immediately disqualified if they touch anything with their second hand.

Events such as this one, surrounded by cowboy boot-wearing, hat-waving, leather-outfitted fans, may seem like something from the Wild West. Especially once you notice the teepee village and the native dances going on a little to the south. But these hair-raising competitions and displays of First Nations culture are all part of the Calgary Exhibition and Stampede.

More than a million visitors flock to the Stampede each year, making it Canada's largest annual event. It's both a celebration of the city and a tribute to the region's past. From the time when the Blackfoot hunted the millions of bison roaming Alberta's plains to the days of the North West Mounted Police posts at Fort Macleod and Fort Calgary and the births of ranching and oil drilling, Calgary's history is a microcosm of frontier life.

Though little more than a century old, Calgary is no longer a frontier city. It boasts a higher percentage of university graduates than any other Canadian metropolis and business people in skyscrapers spend their days guiding and analyzing the growth of the province. For 355 days a year, Calgarians focus on building a thriving city of culture and commerce. But for 10 days each summer, it's obvious that they also maintain a close connection to their roots.

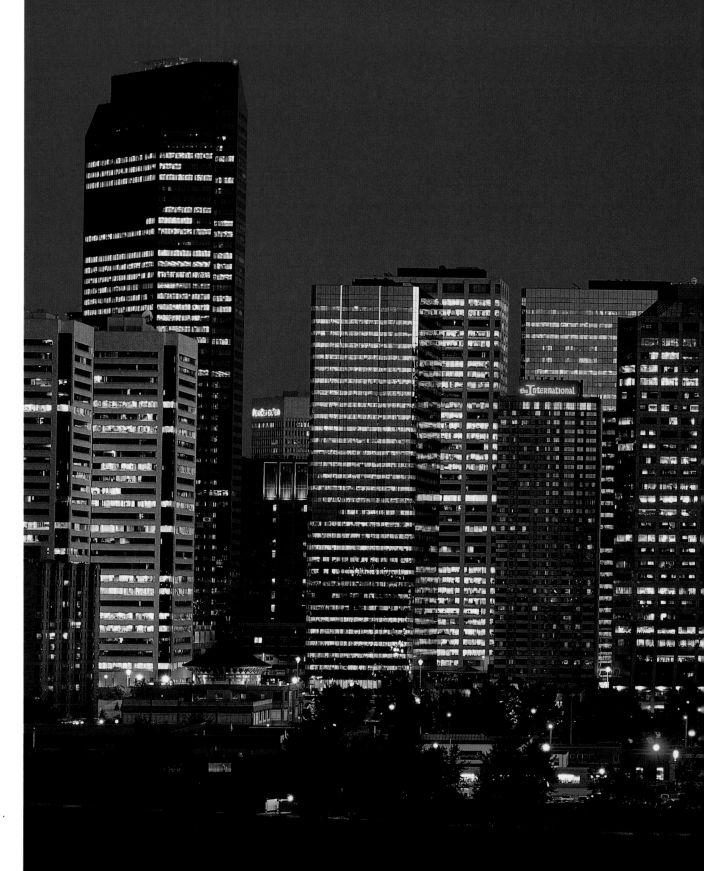

Soon after the Canadian Pacific Railway surveyed its route through southern Alberta towards Kicking Horse Pass, the settlement around Fort Calgary began to grow. A townsite was planned around the junction of the Bow and Elbow rivers and Calgary officially became a city in 1892.

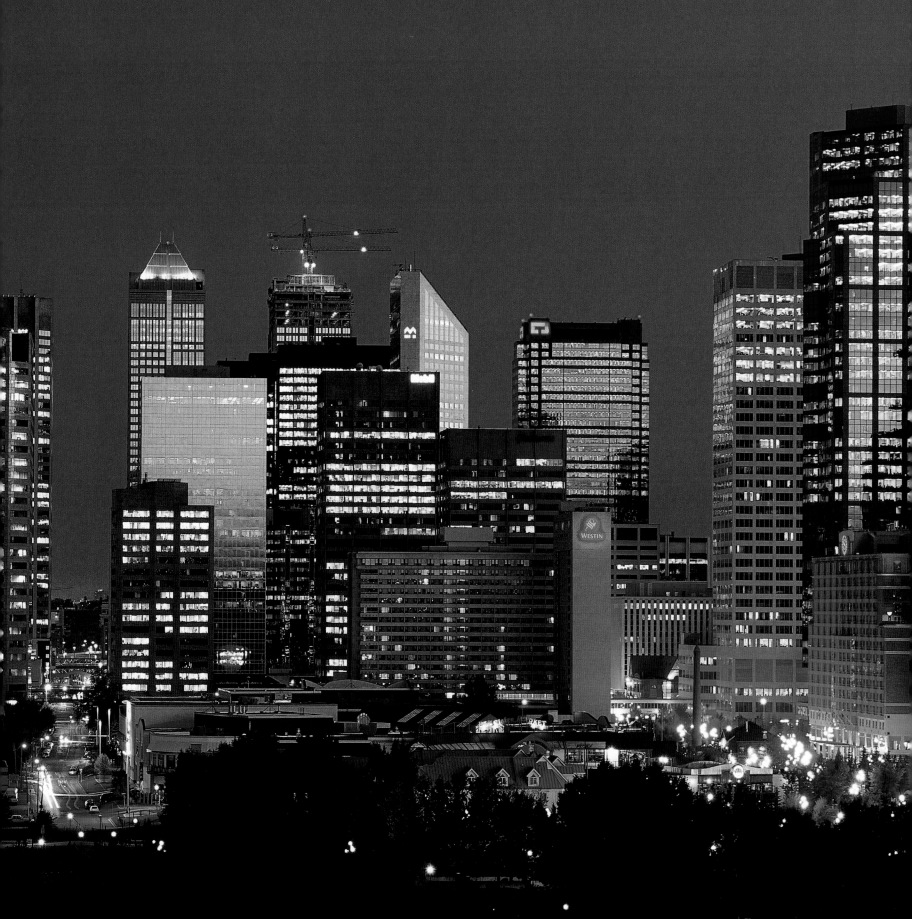

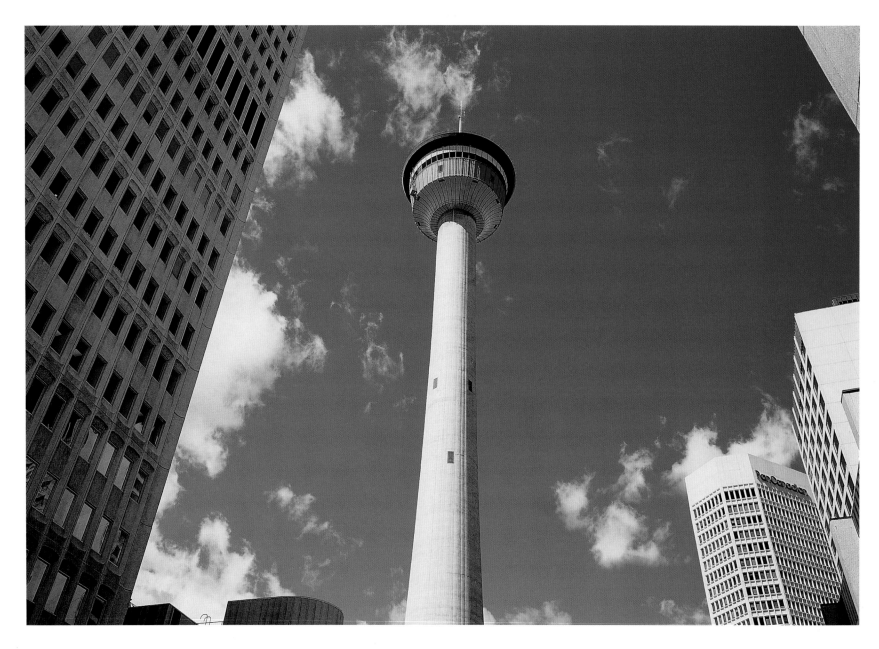

Elevators can whisk visitors up the 190-metre (620-foot) Calgary Tower in 62 seconds, but two 762-step staircases also lead to the top. Though designed for emergency use, these stairs are scaled each year by participants in the Earth Day climb, who raise money for the Alberta Wilderness Association.

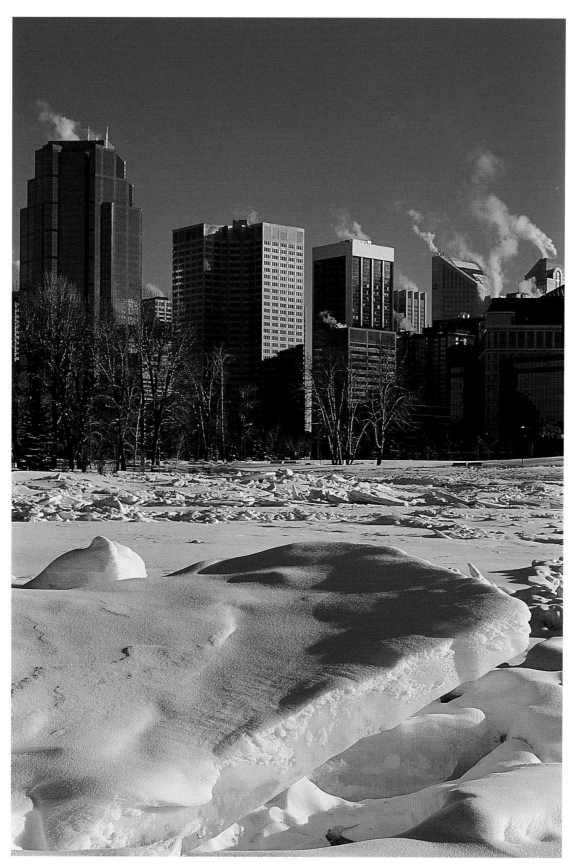

More than 10,000 years ago, the Bow River was an enormous lake formed by glacier meltwater at the end of the last ice age. Scientists call this Glacial Lake Calgary and have found evidence of the ancient lake bottom and surrounding beaches.

A Plus-15, one of Calgary's pedestrian bridges, leads shoppers from one downtown complex to another. It was named for its height —about 15 feet (five metres) above the street. The first of these walkways was built in 1970.

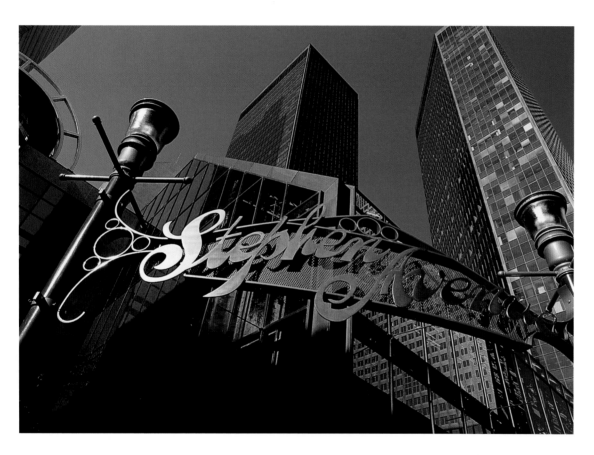

Stephen Avenue is named for Lord George Mount Stephen, first president of the Canadian Pacific Railway. It has been a centre for commercial activity since early in the city's history and still teems with people each afternoon.

Much of Stephen Avenue was destroyed by fire in 1886. Buildings were rebuilt with sandstone, earning Calgary the nickname Sandstone City and ensuring that fire wouldn't destroy the street again.

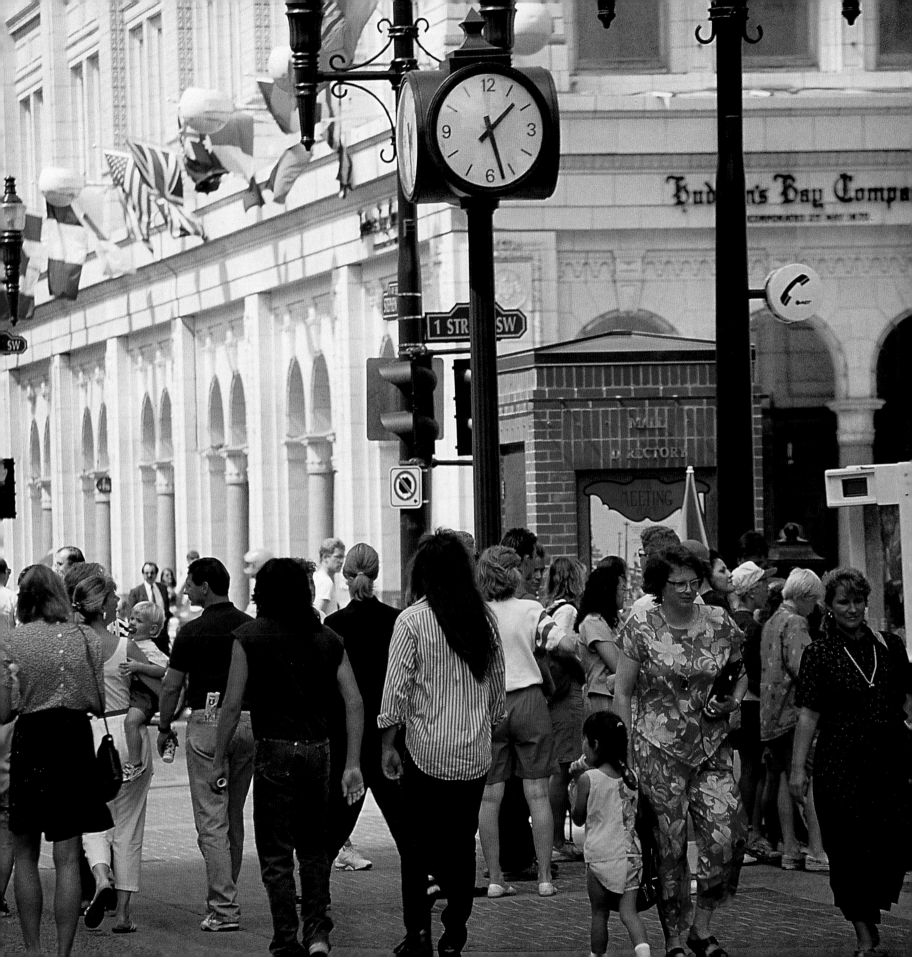

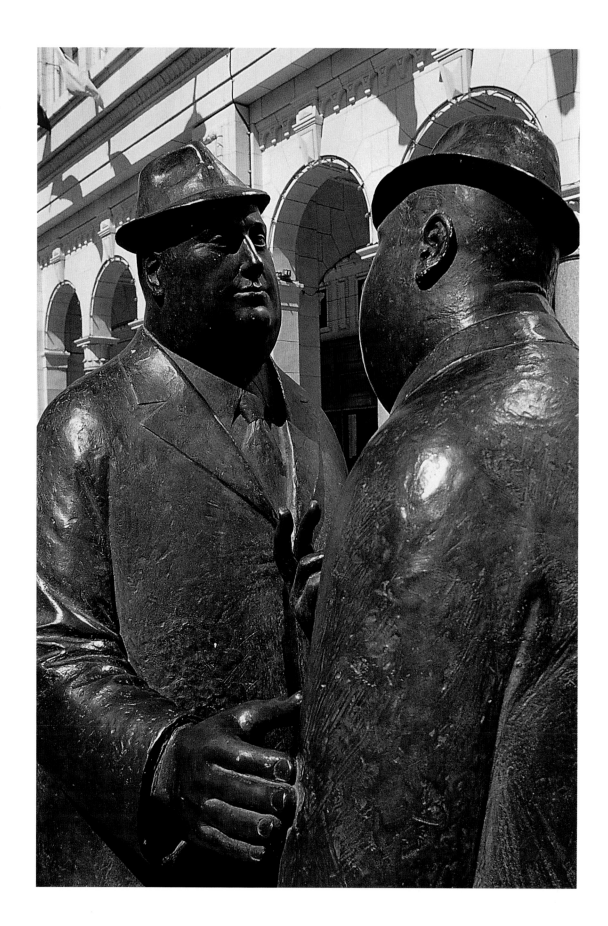

More than 100 works of public art, such as this tribute to commerce on Stephen Avenue, make a stroll through downtown Calgary a fascinating experience.

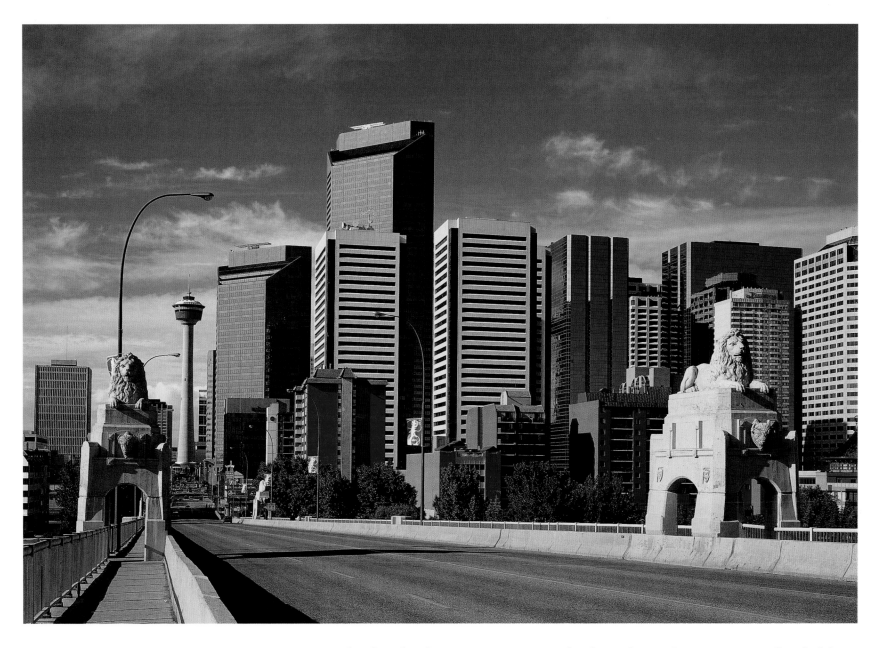

The first bridge at Centre Street, built in the early 1900s, was funded by land owners and speculators. The city purchased the bridge in 1912 after traffic increased and replaced it with a new bridge four years later. The lions on either side were designed by stone mason James L. Thompson.

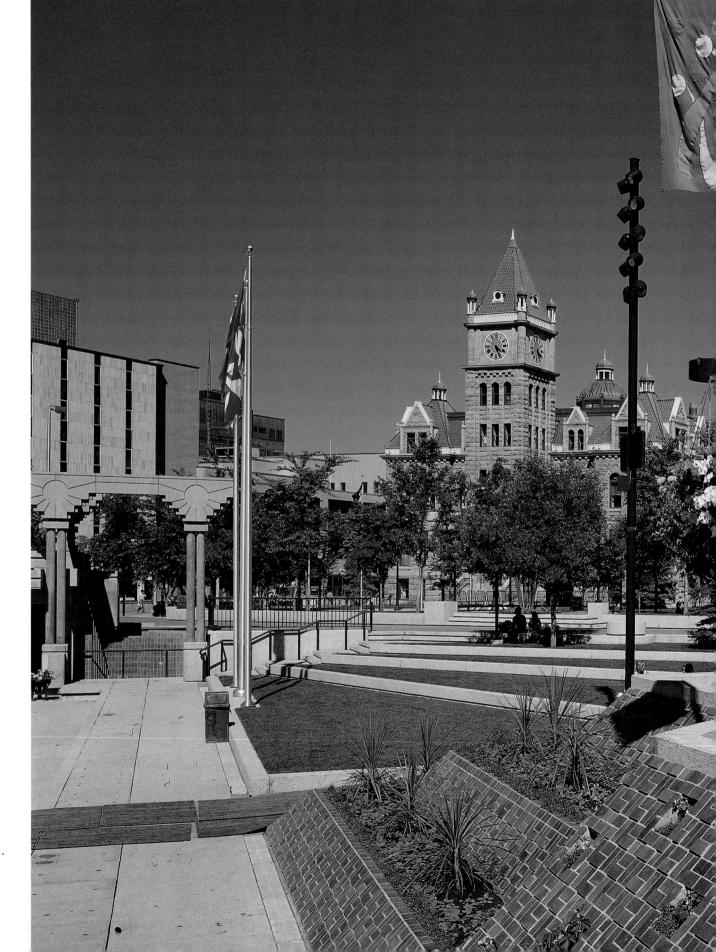

Just across the street from City Hall, Olympic Plaza was the location of the medal ceremonies during the 1988 Winter Olympic Games. Many local residents helped sponsor the games, and their names are inscribed on bricks throughout the plaza.

16

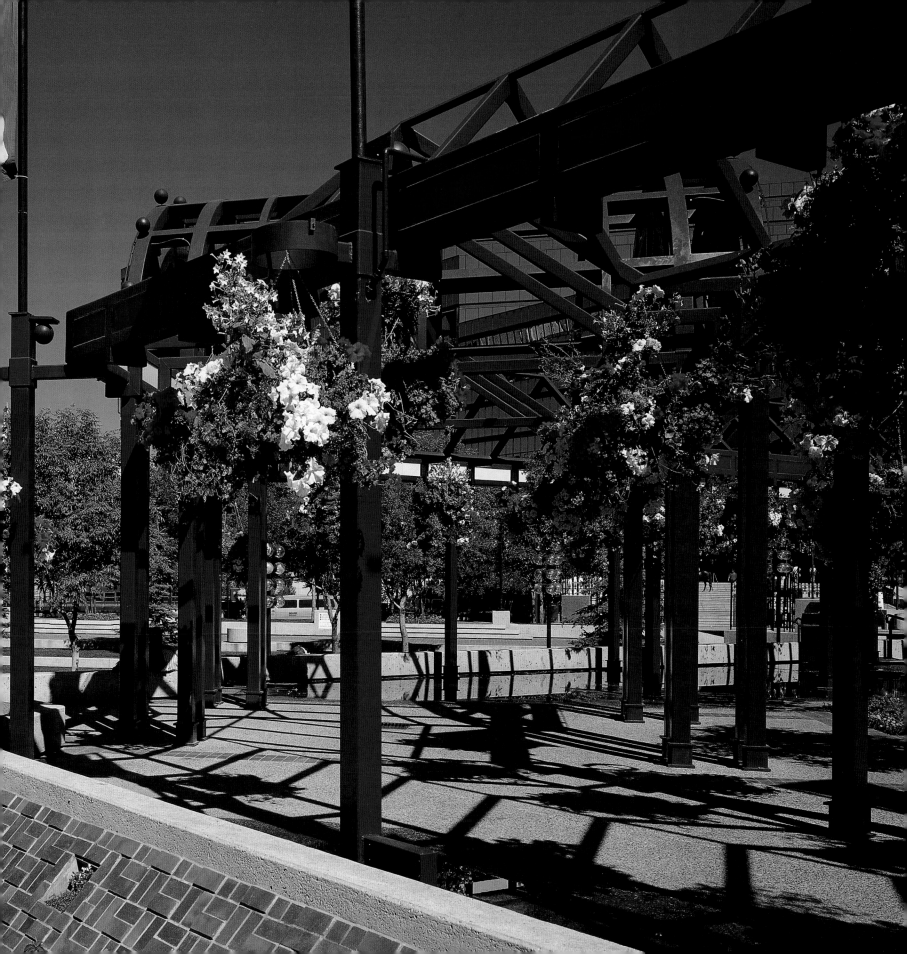

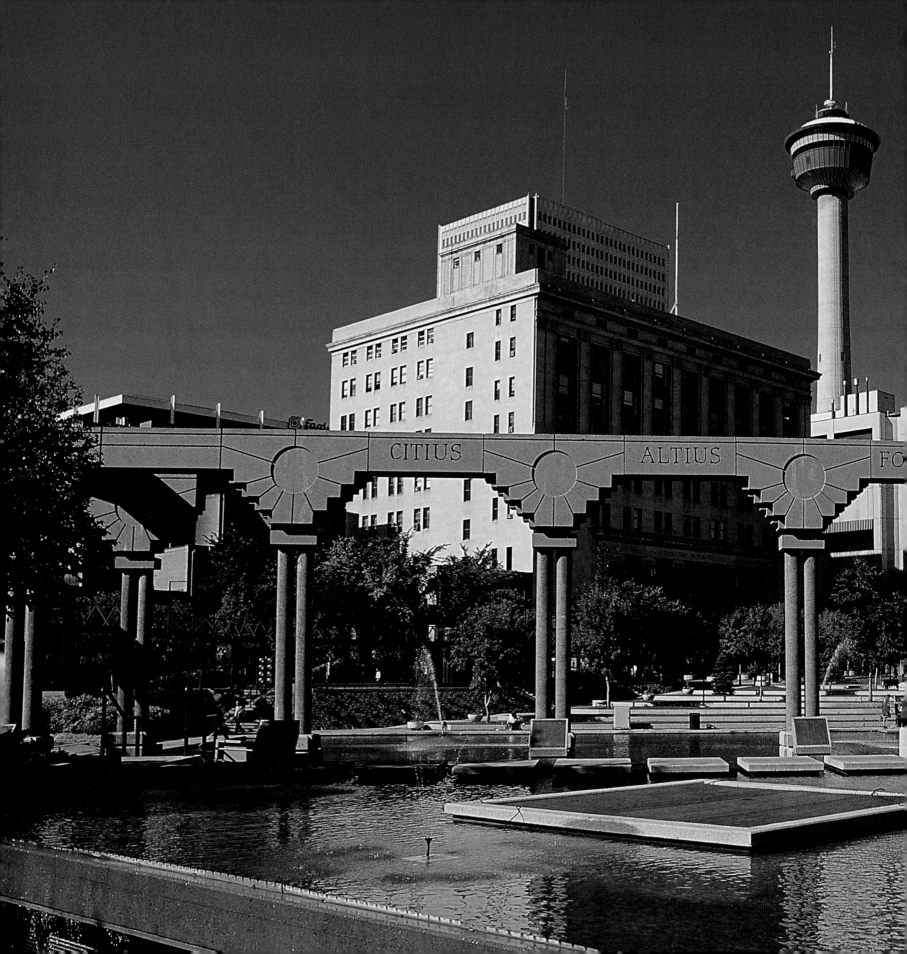

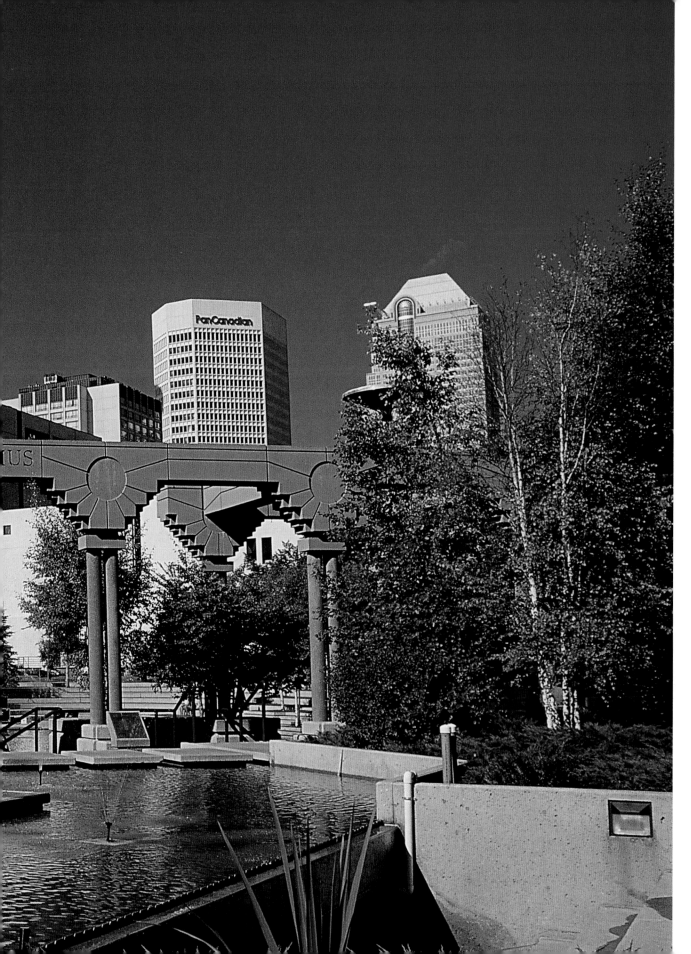

Olympic Plaza is a favourite lunchtime meeting place for downtown workers. In the afternoons and evenings, the plaza is a venue for outdoor concerts, weddings, and festivals, as well as an impromptu stage for street performers.

19

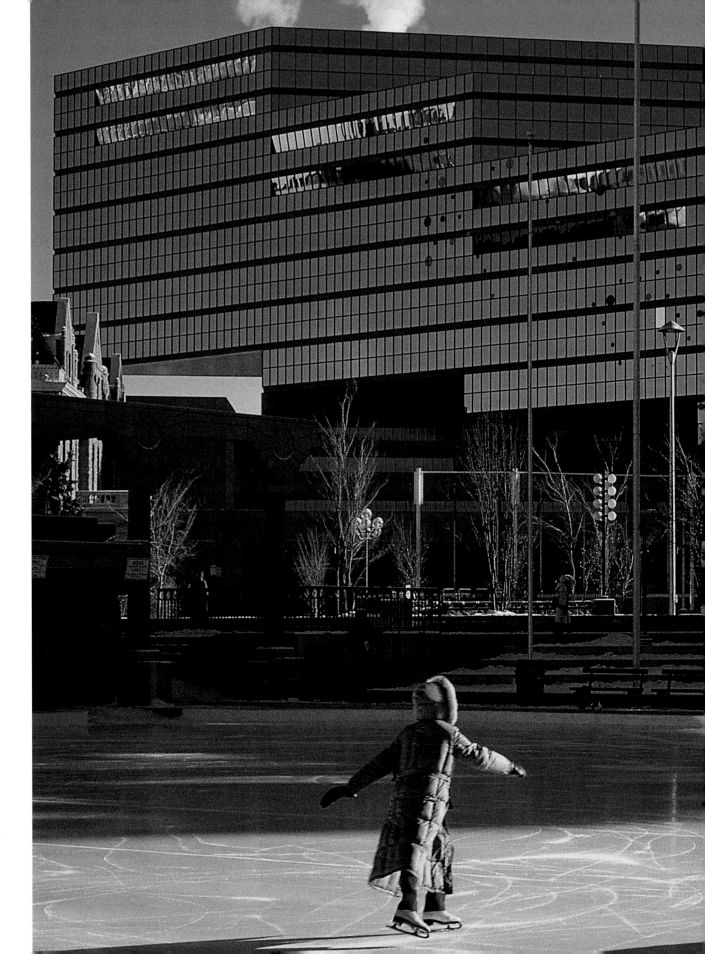

A wading pool near City Hall holds 32,000 litres (8,500 gallons) of water. It can be drained in just a few hours if space in the plaza is needed. In winter, the pool is transformed into a public skating rink.

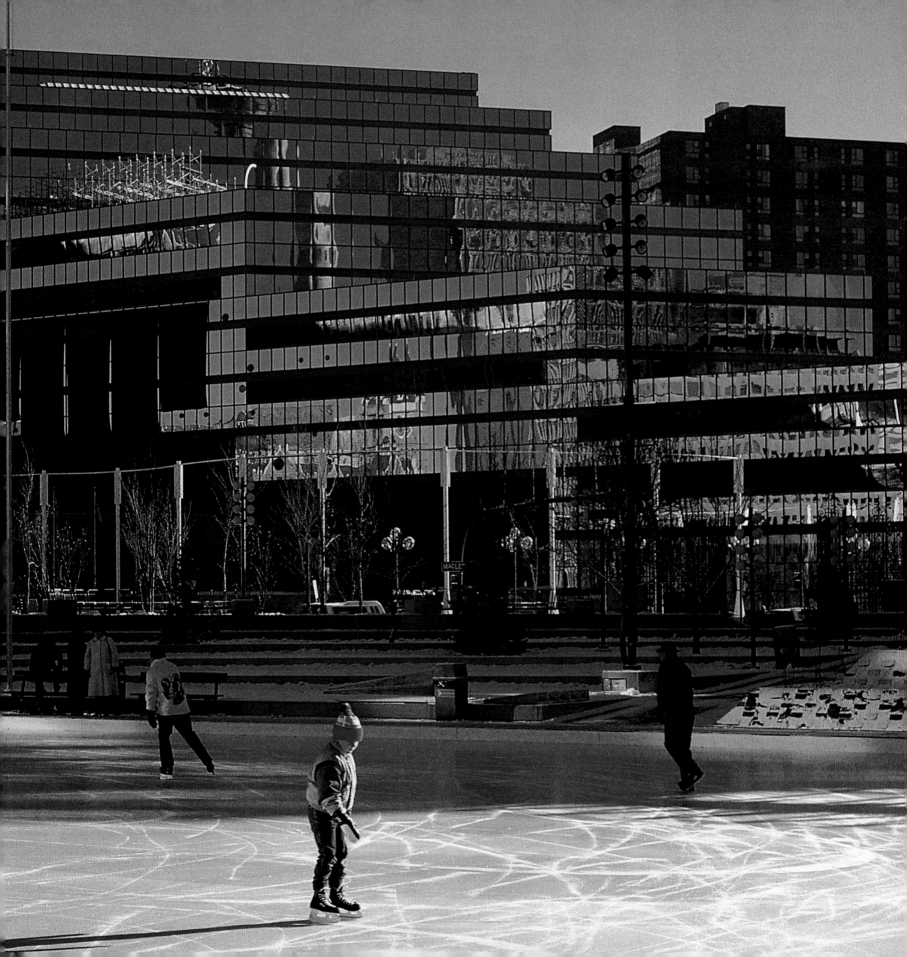

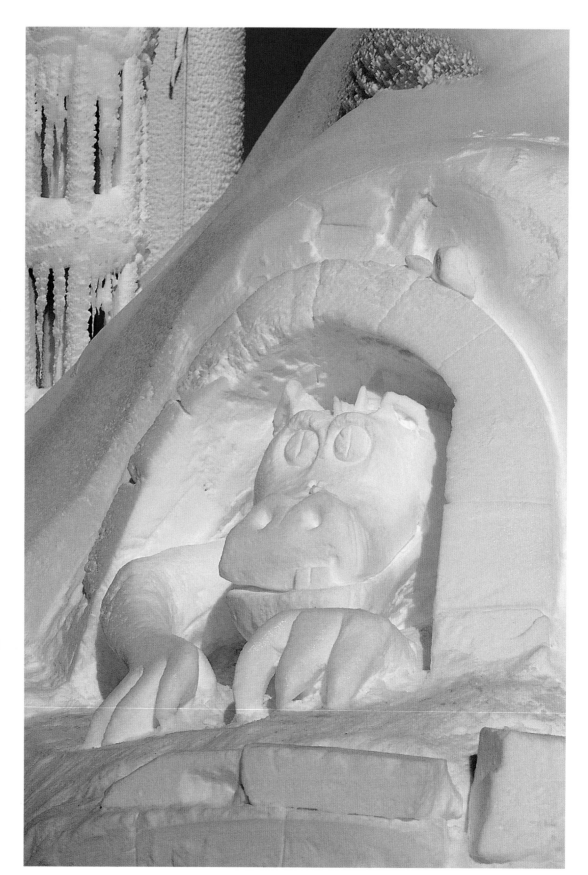

The snow sculpting contest is just one of the events in the Calgary Winter Festival, held each February. The 10-day celebration begins with a parade and includes curling, ice-sculpting, skating, skiing, children's activities, concerts, and more.

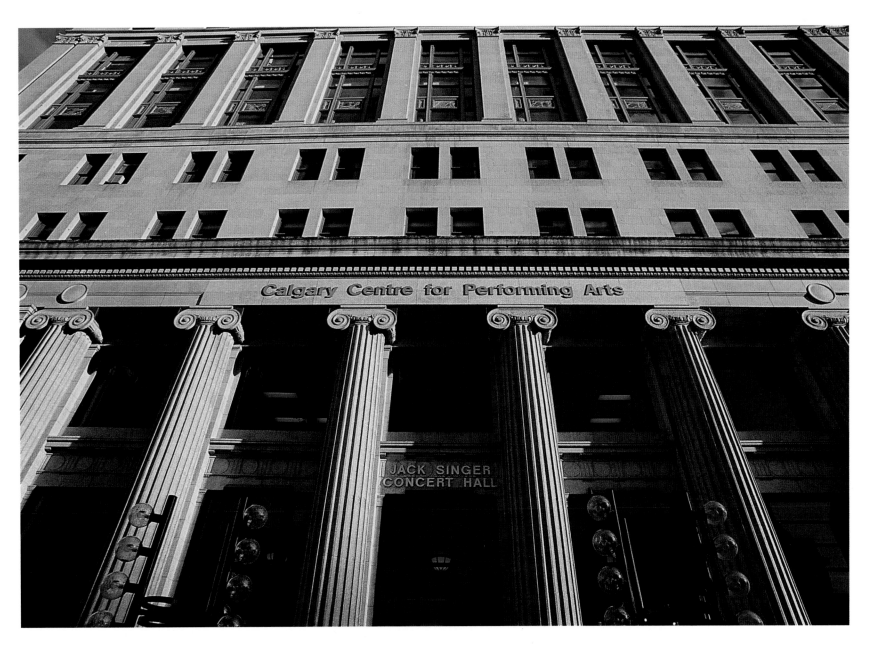

The theatres within the Calgary Centre for Performing Arts—the Jack Singer Hall and the Max Bell, Martha Cohen, Engineered Air, and Secret theatres—host events from Calgary Philharmonic Orchestra performances to community concerts.

There are more than 3,750 businesses based in downtown Calgary, including over 200 cafés and restaurants, 100 theatres, concert halls, and nightclubs, and 800 stores and boutiques.

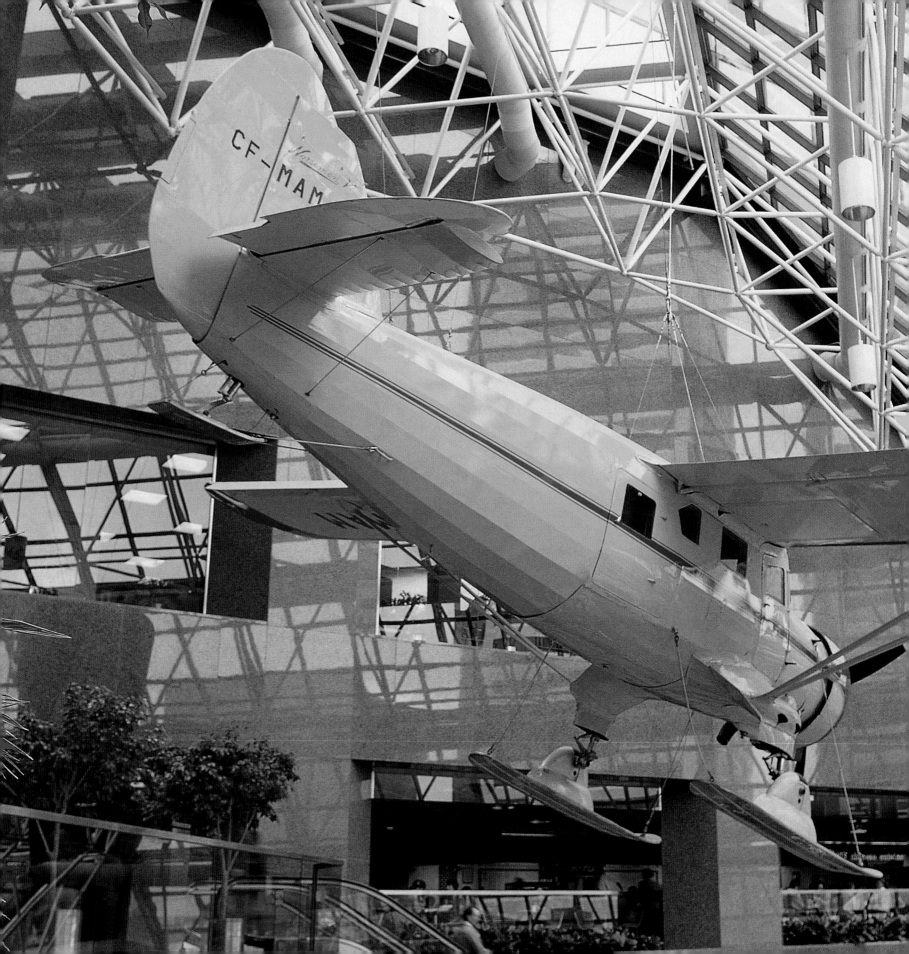

A Norseman bush plane hangs inside Calgary's Petro Canada building. The plane, designed for the rigours of the Canadian north, was created by Robert Noorduyn in 1934. About 900 of the planes were produced. They flew extensively in British Columbia, Alberta, Manitoba, Ontario, and the Northwest Territories.

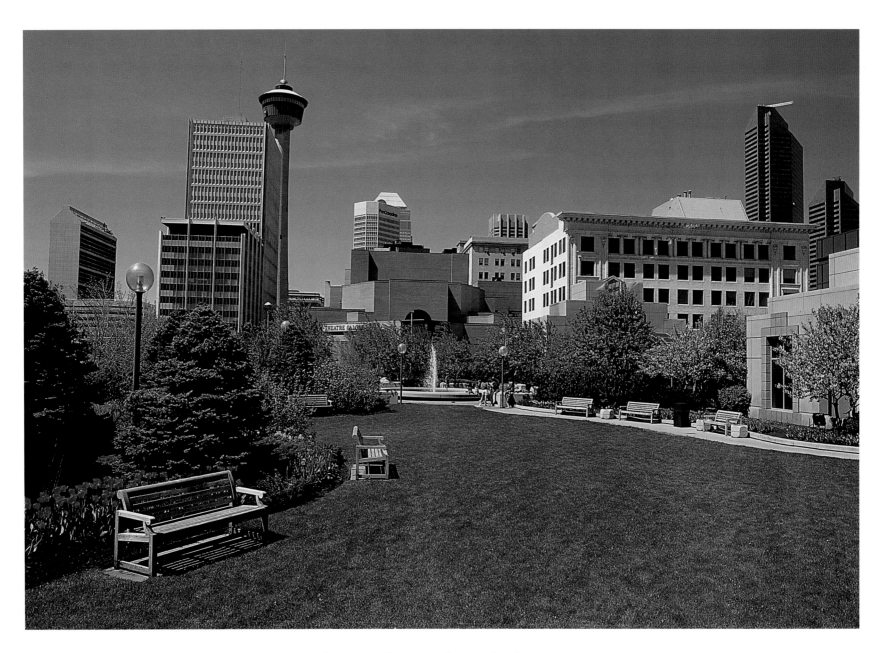

More than 7 million visitors arrive in Calgary each year, drawn both
by the lively attractions of the city and Calgary's amazing natural
setting. The city maintains 2,700 parks, from this downtown oasis
to the sprawling Fish Creek Park.

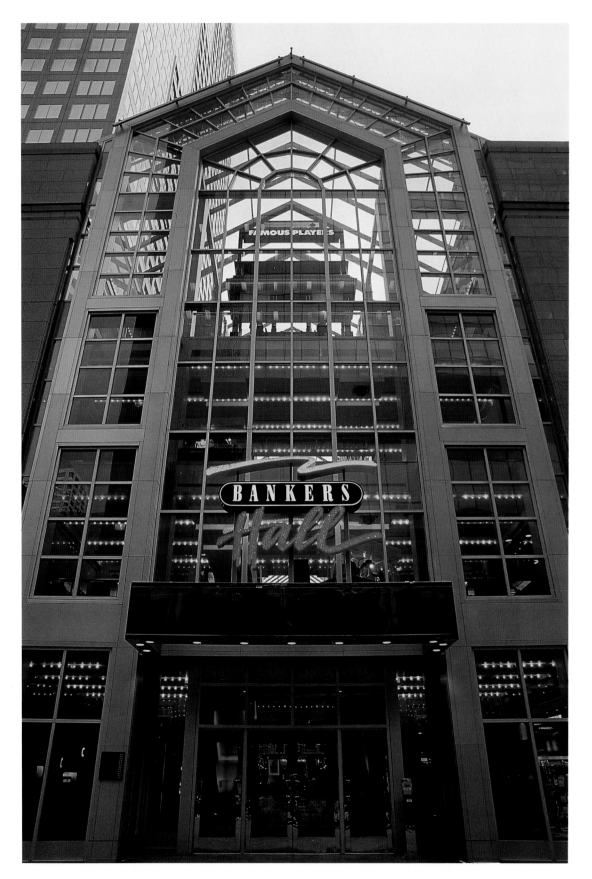

Filled with clothing shops, gift boutiques, music stores, and more, Banker's Hall is one of several shopping complexes at the centre of the city, linked by pedestrian walkways.

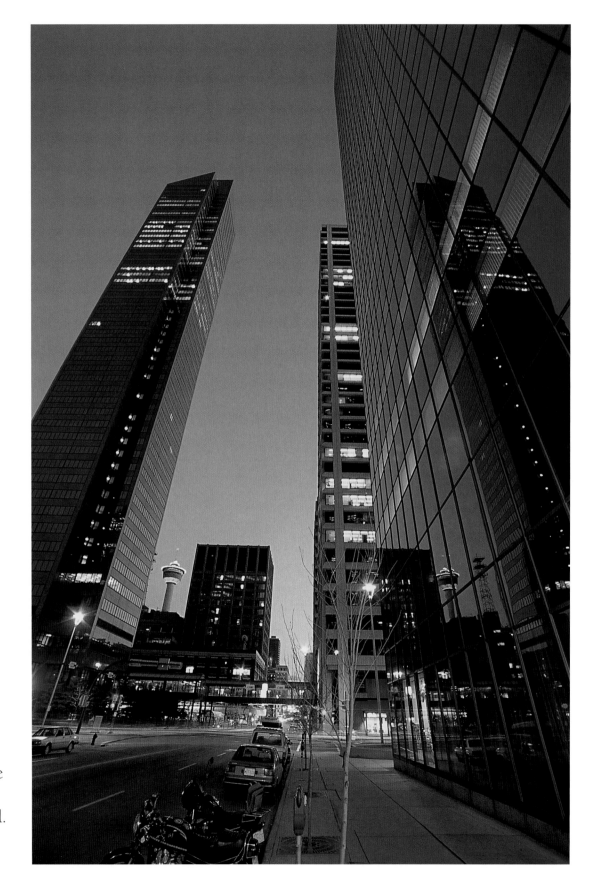

When the North West Mounted Police arrived at the confluence of the Bow and Elbow rivers, the commanding officer, Ephrem Brisebois, suggested that the outpost be named Fort Brisebois. Calgary, the name of a cove in Scotland, was suggested by Colonel James F. Macleod.

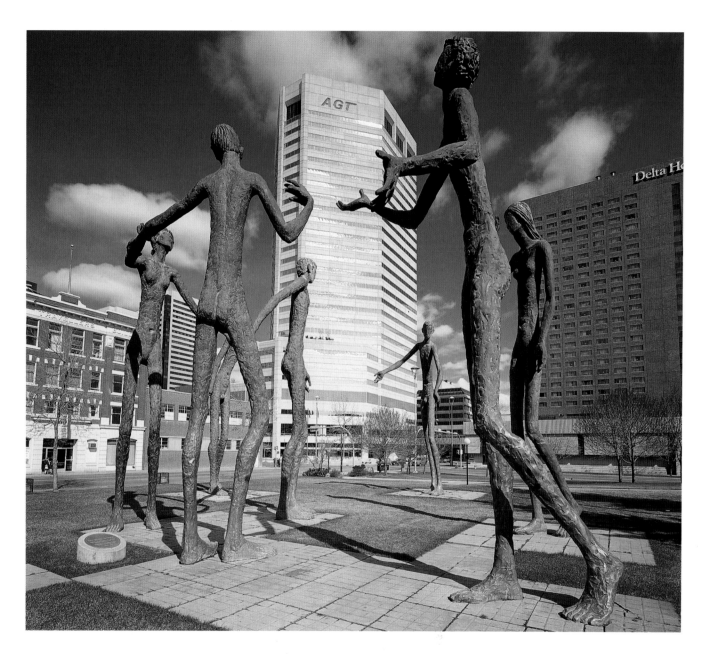

Because the Rocky Mountains block clouds from the west, Calgary lies in a rain shadow—an area of low precipitation. The sky is generally clear, and warm Chinook winds keep winter temperatures mild.

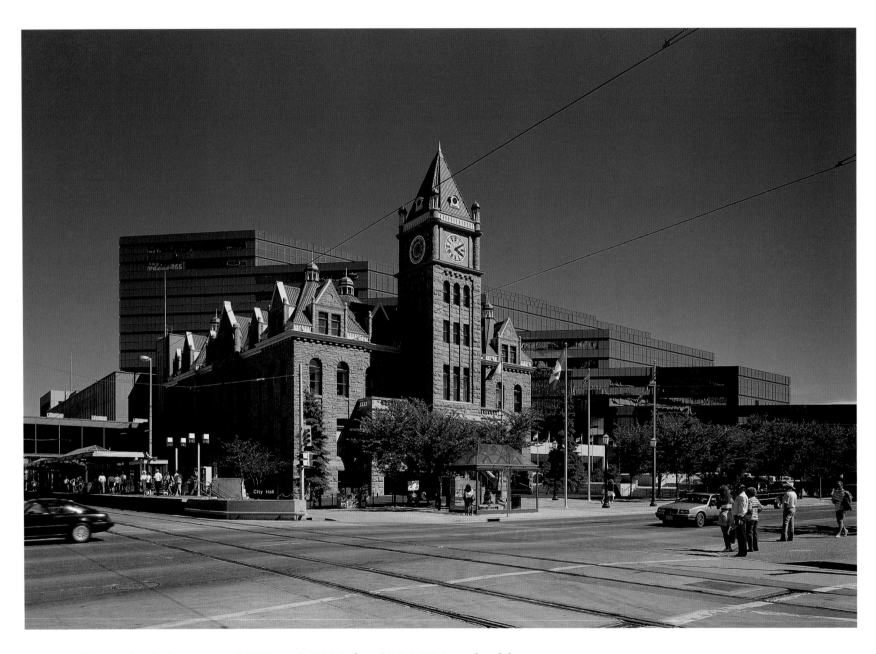

City Hall was built between 1907 and 1911 for $300,000—double
the estimated cost. Because of the cost overruns, some of the planned
architectural features remained unfinished until a restoration project
in 1997.

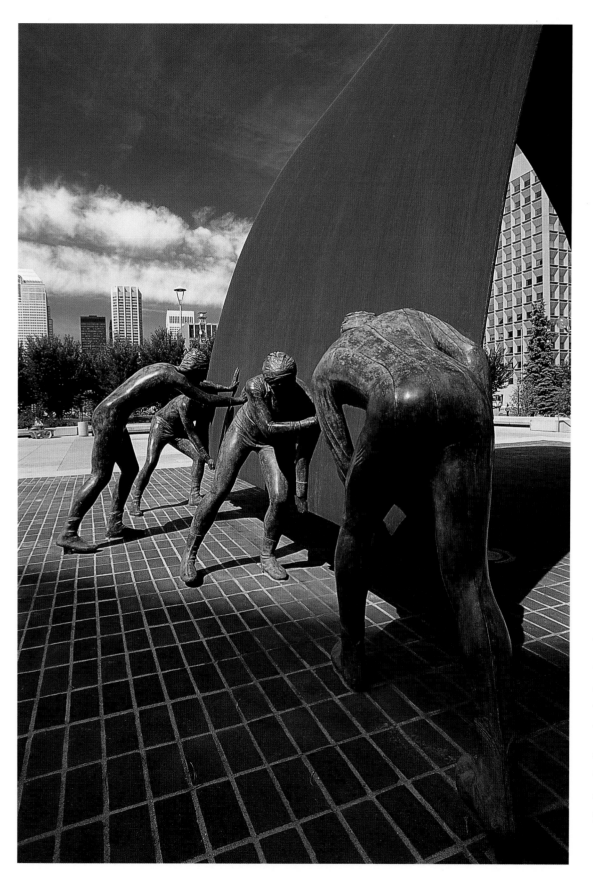

The Municipal Building, where 2,000 city employees work, was designed around a 12-storey atrium, allowing natural light to reflect throughout the building. About 30,000 cubic metres (39,200 cubic yards) of concrete were used in construction.

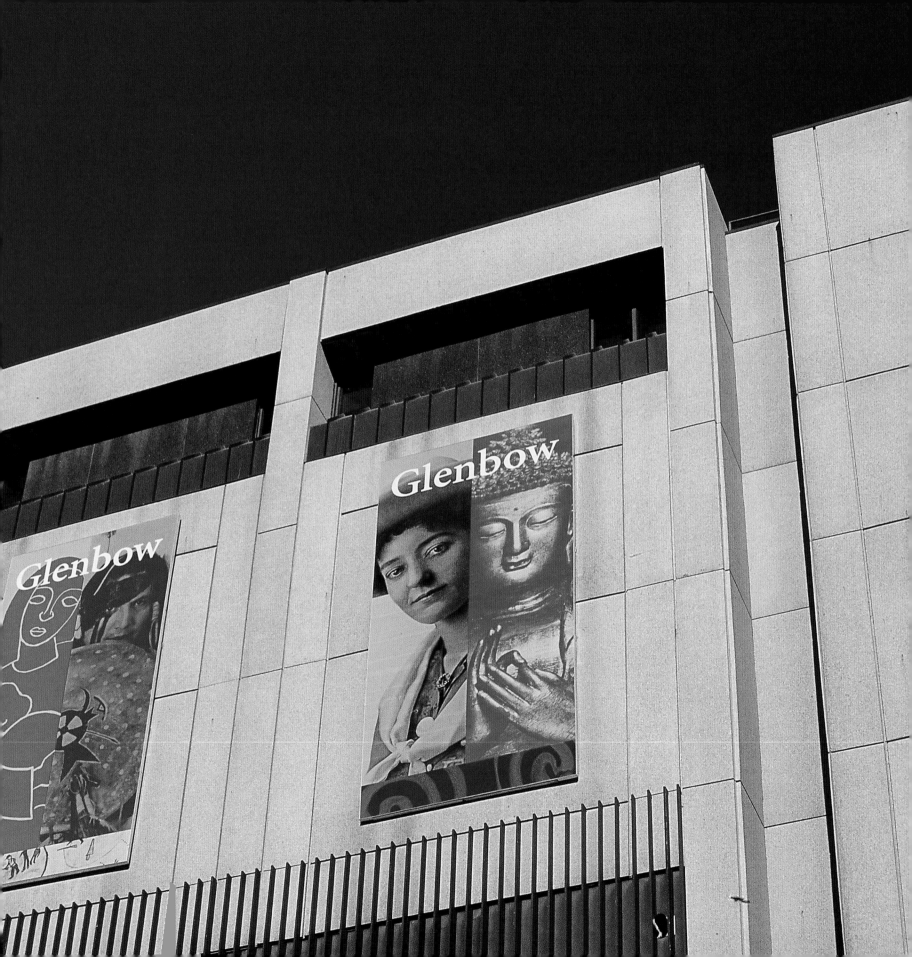

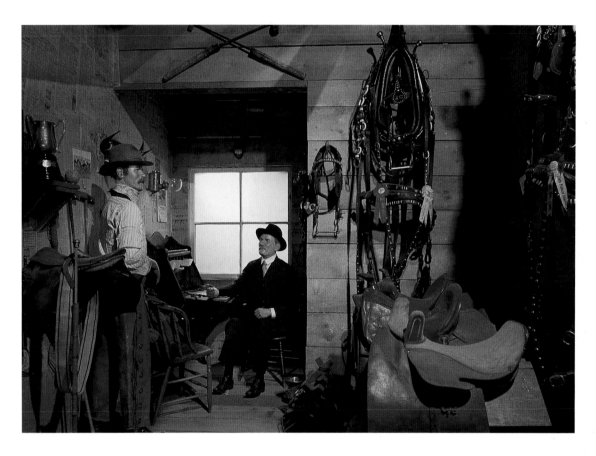

Pottery created by early Alberta settlers, a North West Mounted Police uniform, and a Blackfoot shirt embroidered with porcupine quills—displays at the Glenbow Museum explore Western Canada's history.

Lawyer, rancher, and oil baron Eric Harvie spent his life collecting items from Alberta's history, Canadian art, and artifacts from around the world. The Glenbow-Alberta Institute was established to display the more than one million pieces he donated to the province in 1966.

Chinese immigrants arrived in Calgary in the late 19th century to work on the railroads. The city's Chinatown is a neighbourhood of import shops, restaurants and markets.

The ornate dome of the Chinese Cultural Centre was modeled after the Temple of Heaven in Beijing, China, and artisans from Beijing helped design and build the structure. The centre includes a museum, gallery, library, meeting rooms, and classrooms.

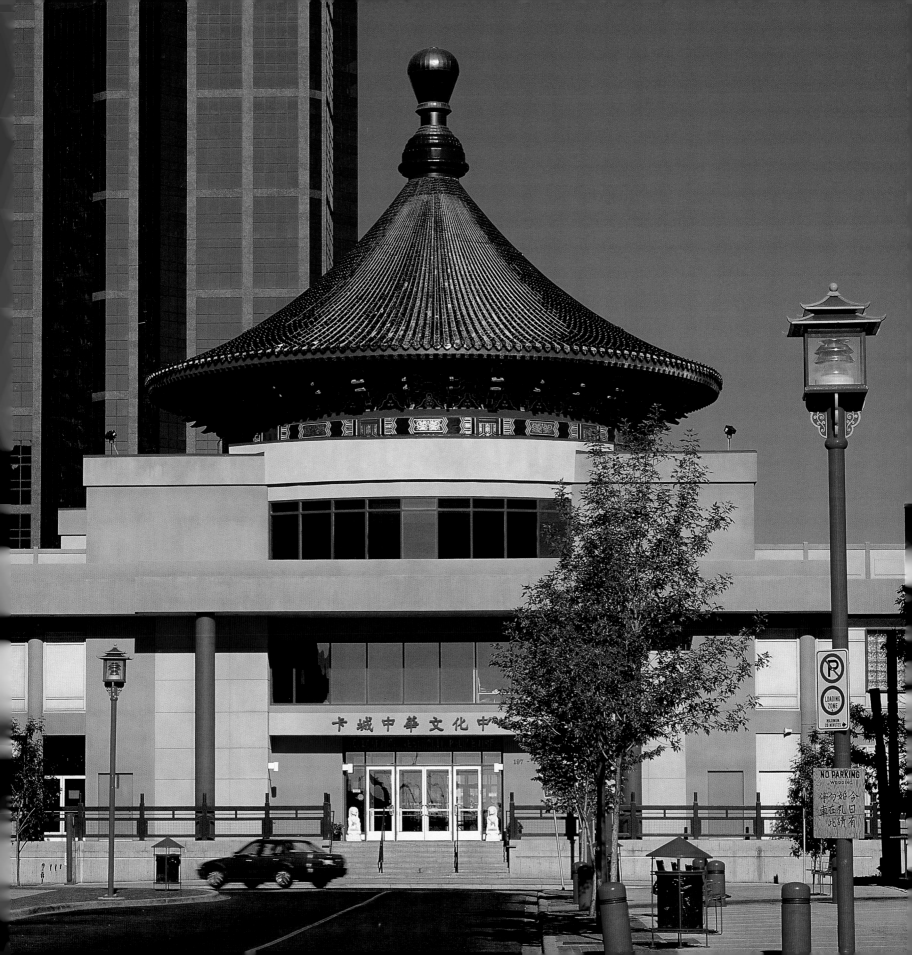

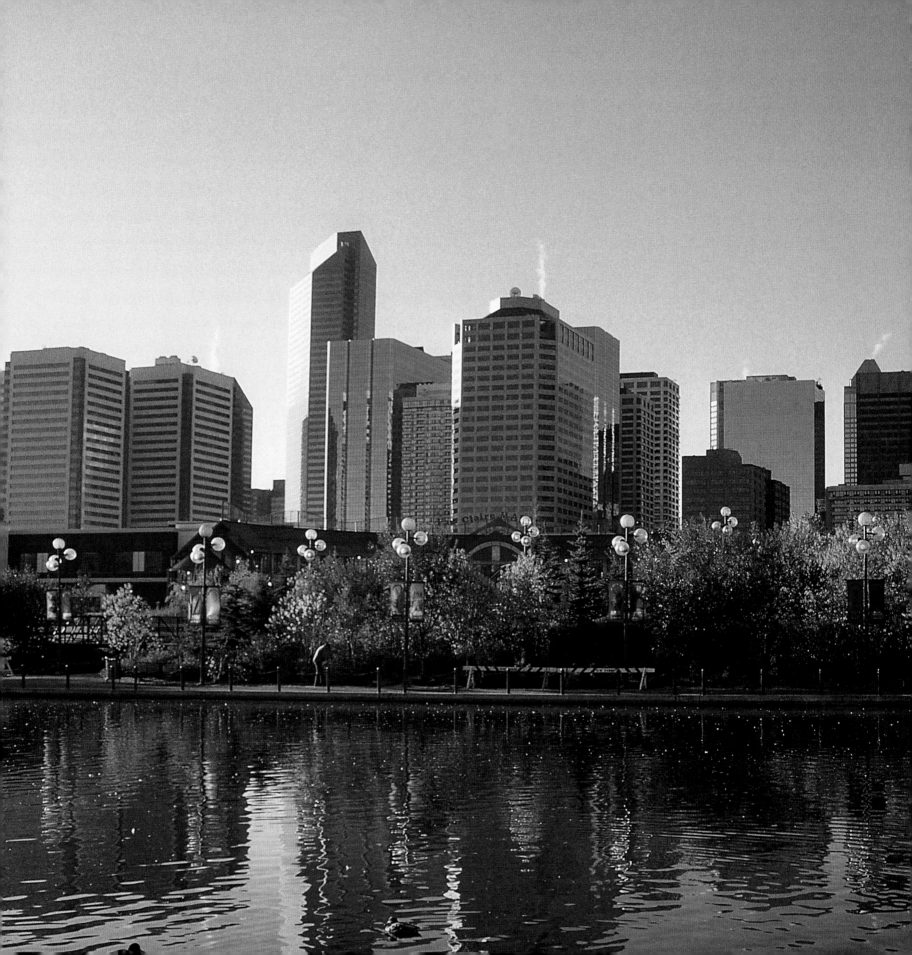

The festive atmosphere of Eau Claire Market, the nearby recreation centre, and the facilities of Prince's Island Park make this area a favourite destination for families..

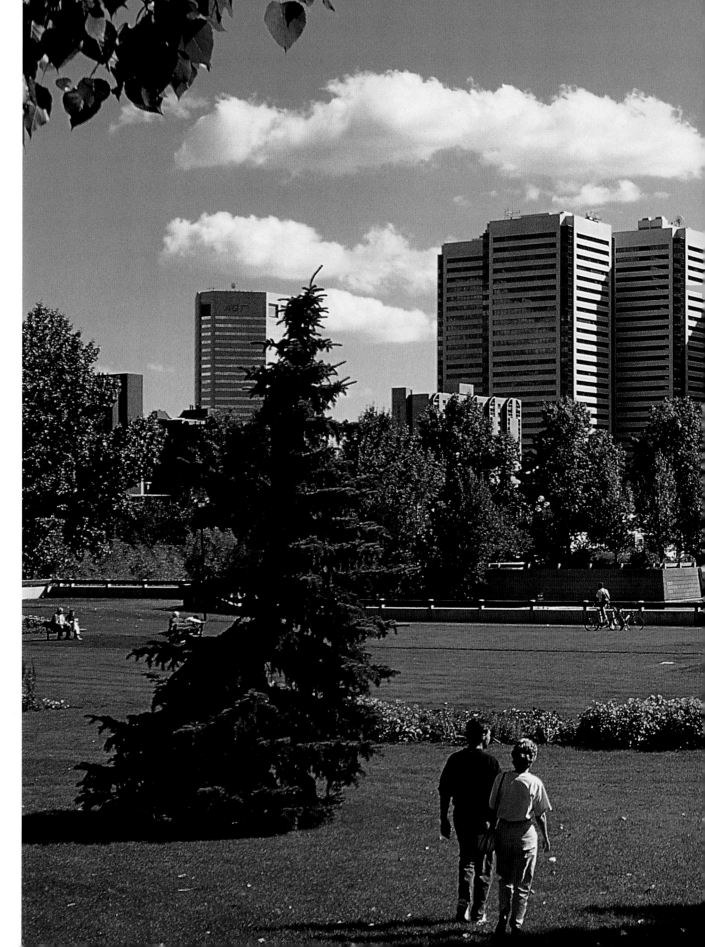

Prince's Island was once an industrial centre, home to a busy sawmill and lumber-yard. It is named for the manager of the mill, Peter Prince. Today, the island has been transformed into an oasis of relaxing green space and busy sports facilities.

40

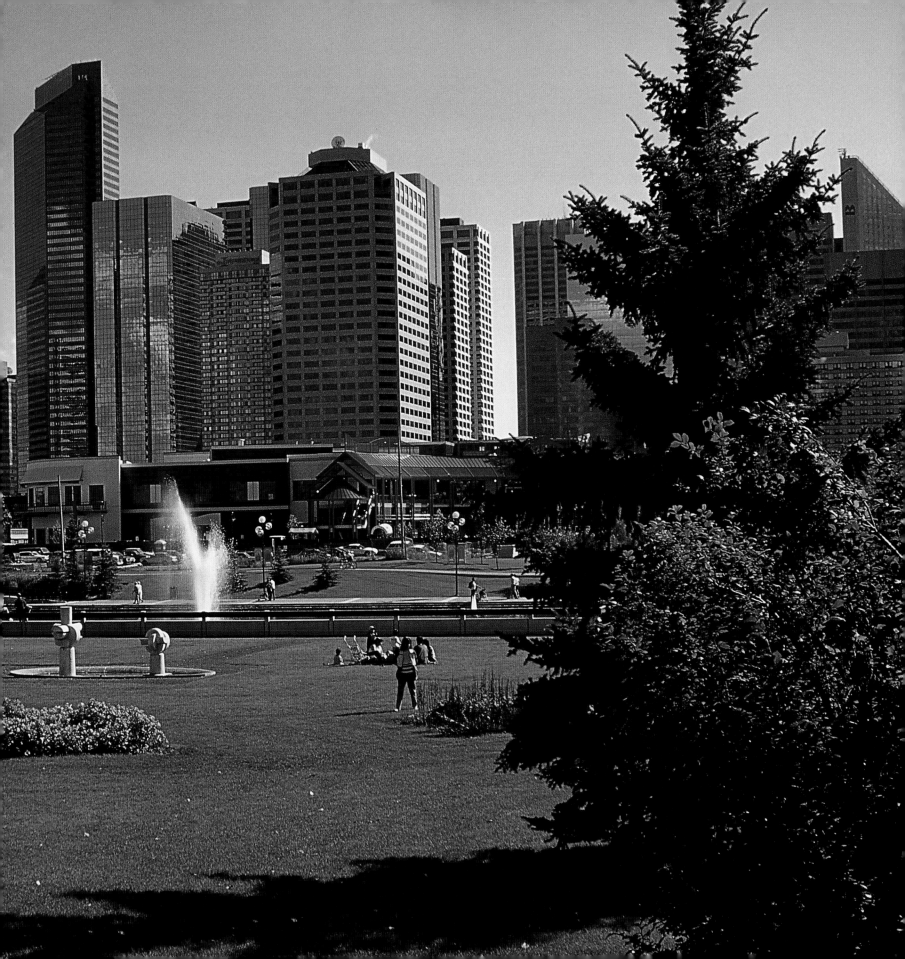

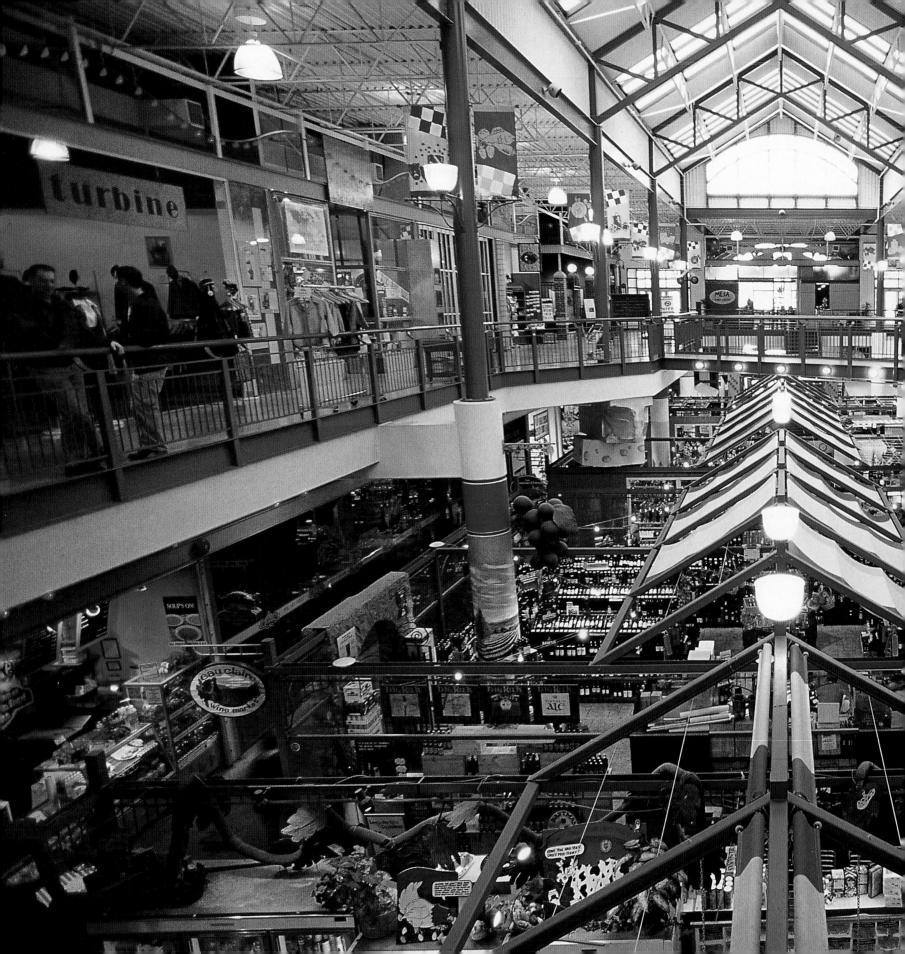

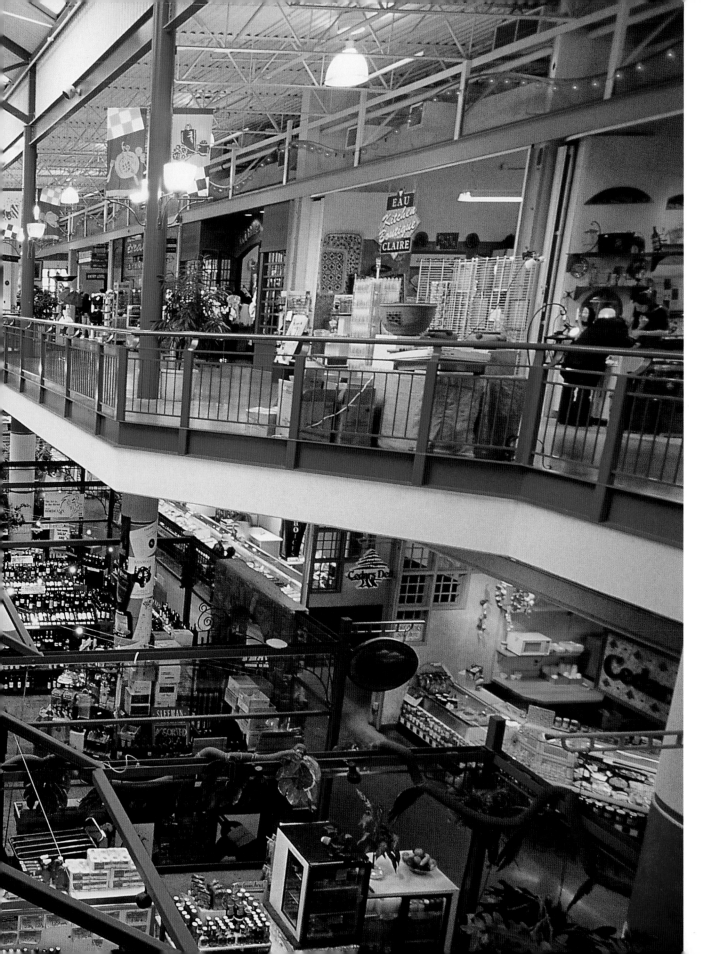

From cinemas—
including a 300-seat
IMAX Theatre—
to galleries and
boutiques, the Eau
Claire Market has
something to tempt
every visitor. The
240,000-square-foot
complex includes
a lively food market
where vendors
display seafood,
produce, pastries,
and more.

43

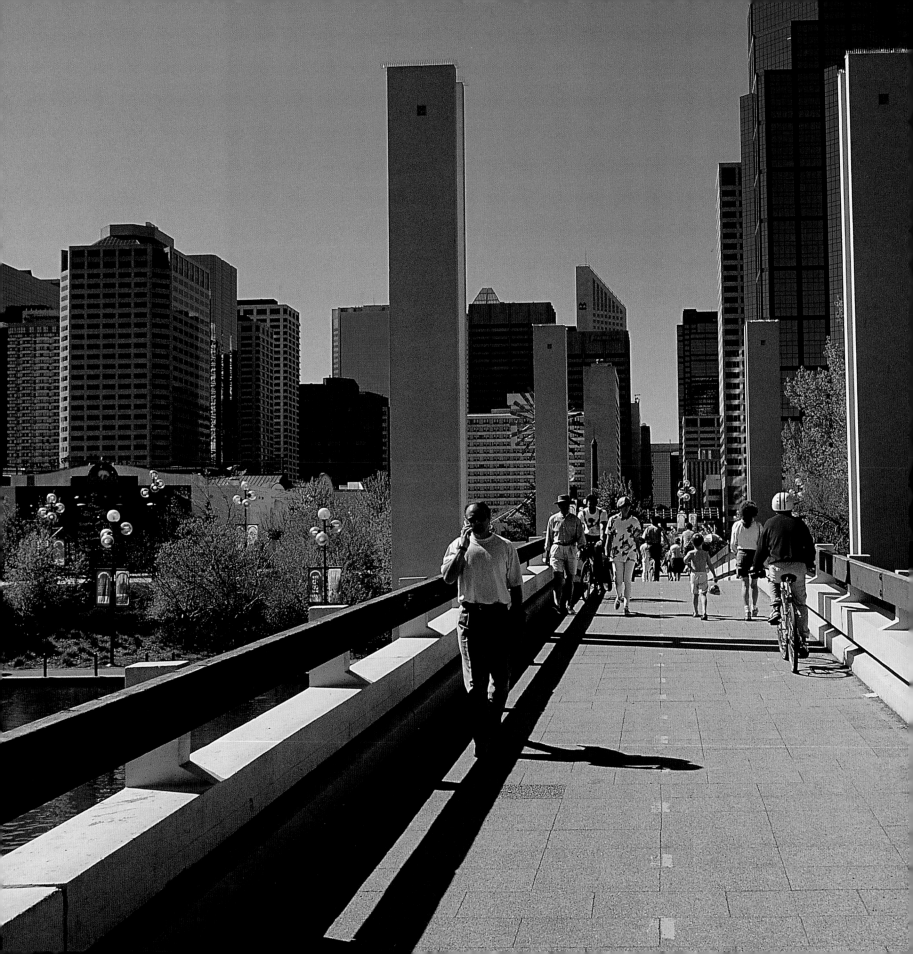

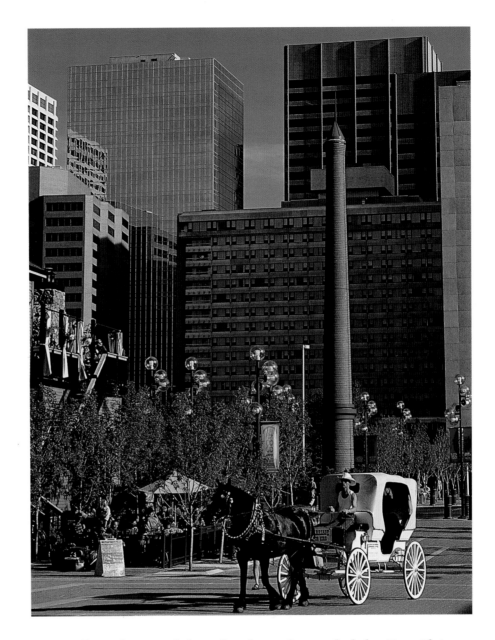

The mill workers and their families who settled the Eau Claire area immigrated from Eau Claire, Wisconsin, and named their new settlement after their home town. Several of the early 19th-century homes from this area have been moved to Heritage Park.

A pedestrian bridge, part of Calgary's 223-kilometre (139-mile) system of walking and cycling paths, connects Prince's Island Park with downtown. For city residents, access to the park's lagoon, band shell, sports fields, and wading pool is just minutes away.

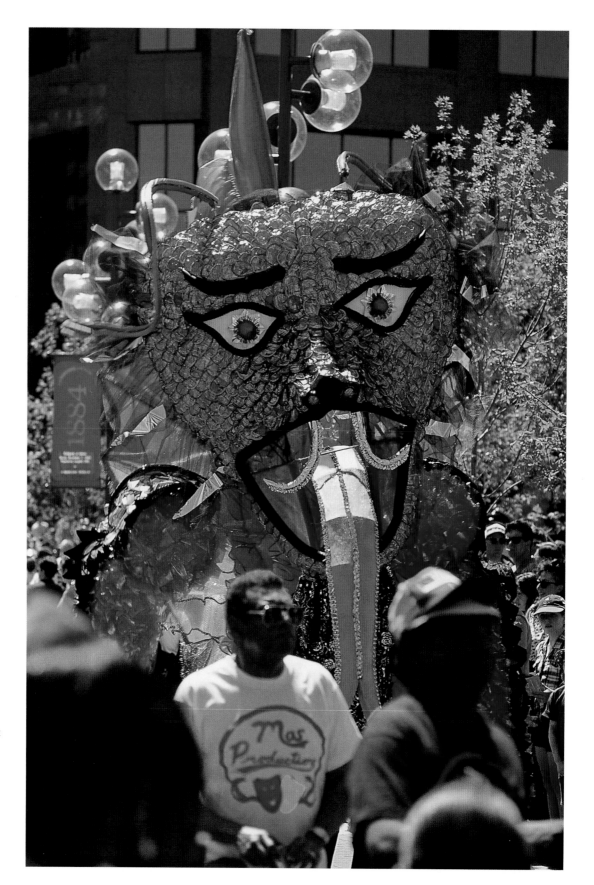

Calgary hosts diverse festivals and celebrations throughout the year, including the International Children's Festival in May, the Caribbean-inspired Carifest in June, the Heritage Day party at Prince's Island each August, and the First Night Festival held each New Year's Eve.

46

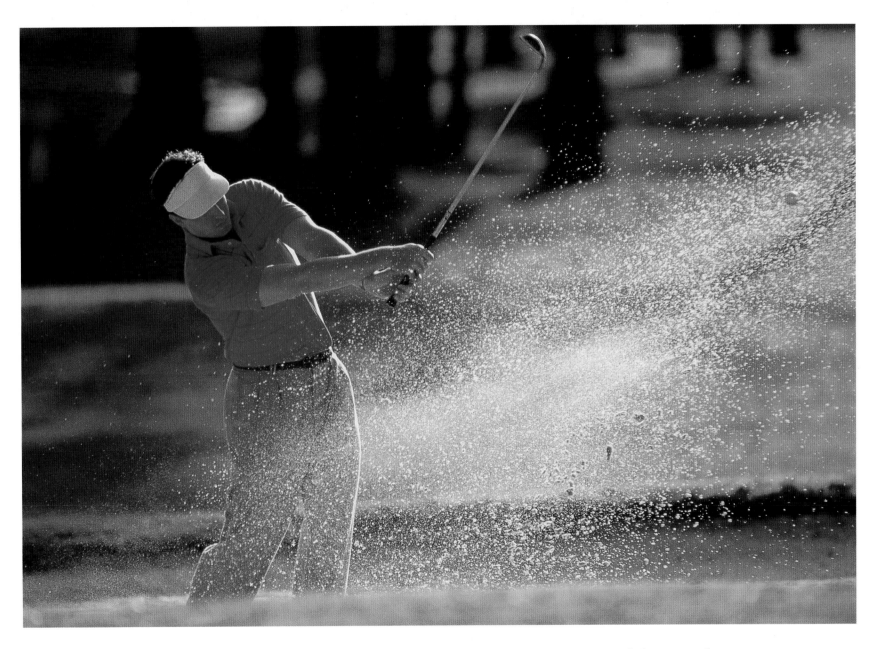

When the Calgary Golf and Country Club opened in 1897, no one would have predicted the popularity the game would achieve. Calgary now has eight public golf courses as well as several private and semi-private courses.

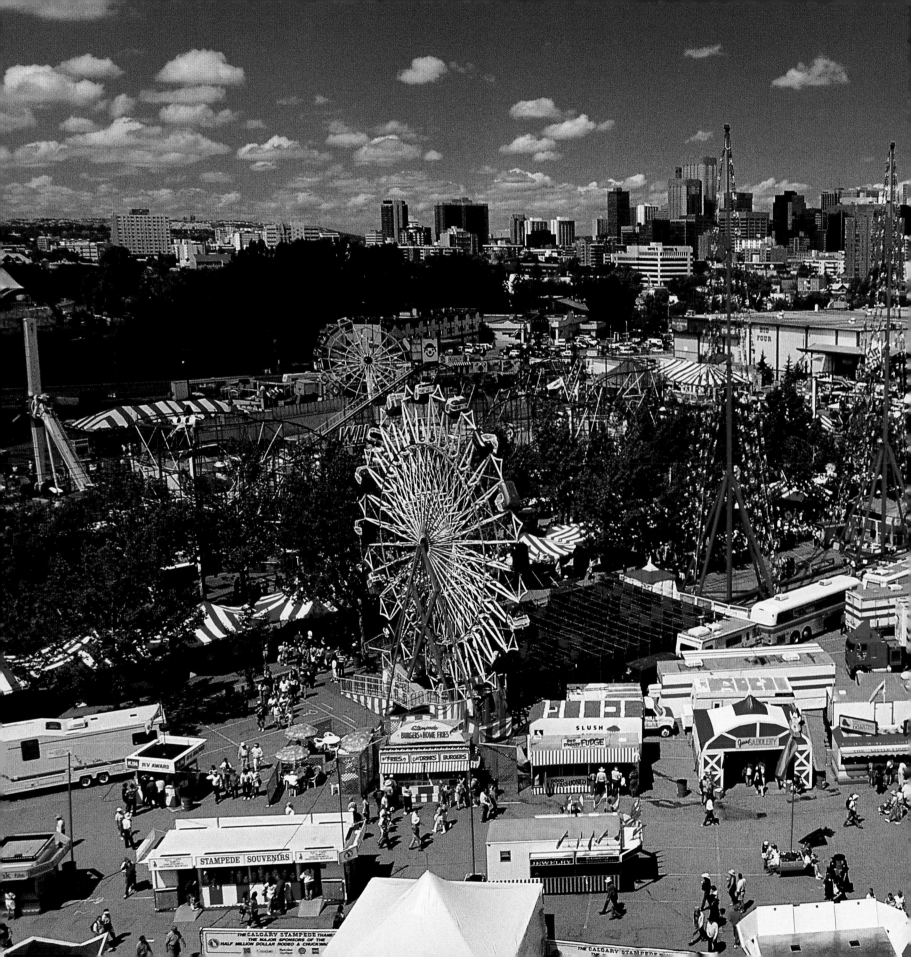

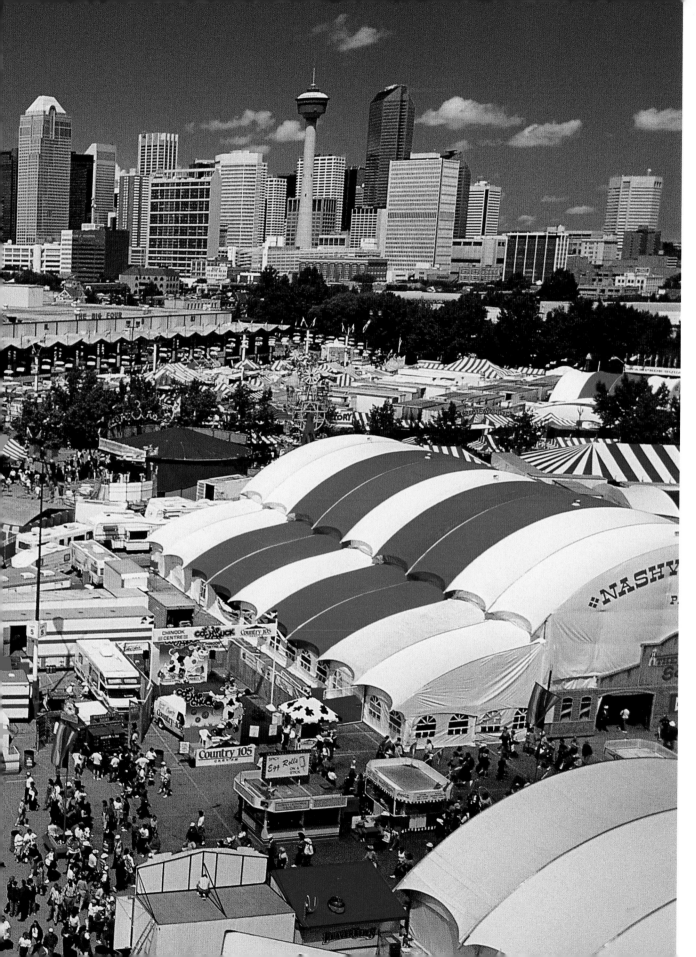

The Calgary Exhibition and Stampede is the largest annual event in Canada. The July festivities include a 10-day rodeo, a parade, games, exhibits, and shows. The events draw 100,000 people a day to Stampede Park.

49

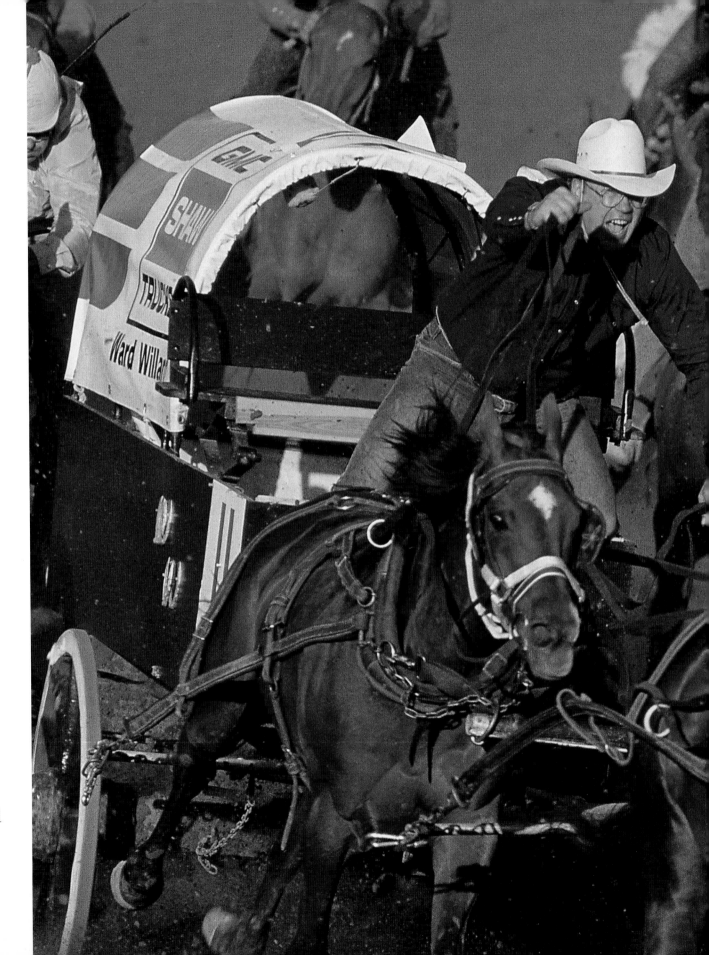

Drivers competed in the world's first official chuckwagon races at the 1923 Stampede. Now, wagon drivers compete in the Rangeland Derby, driving their teams around the track in a dust-raising, heart-pounding race some have compared to the chariot races of ancient Rome.

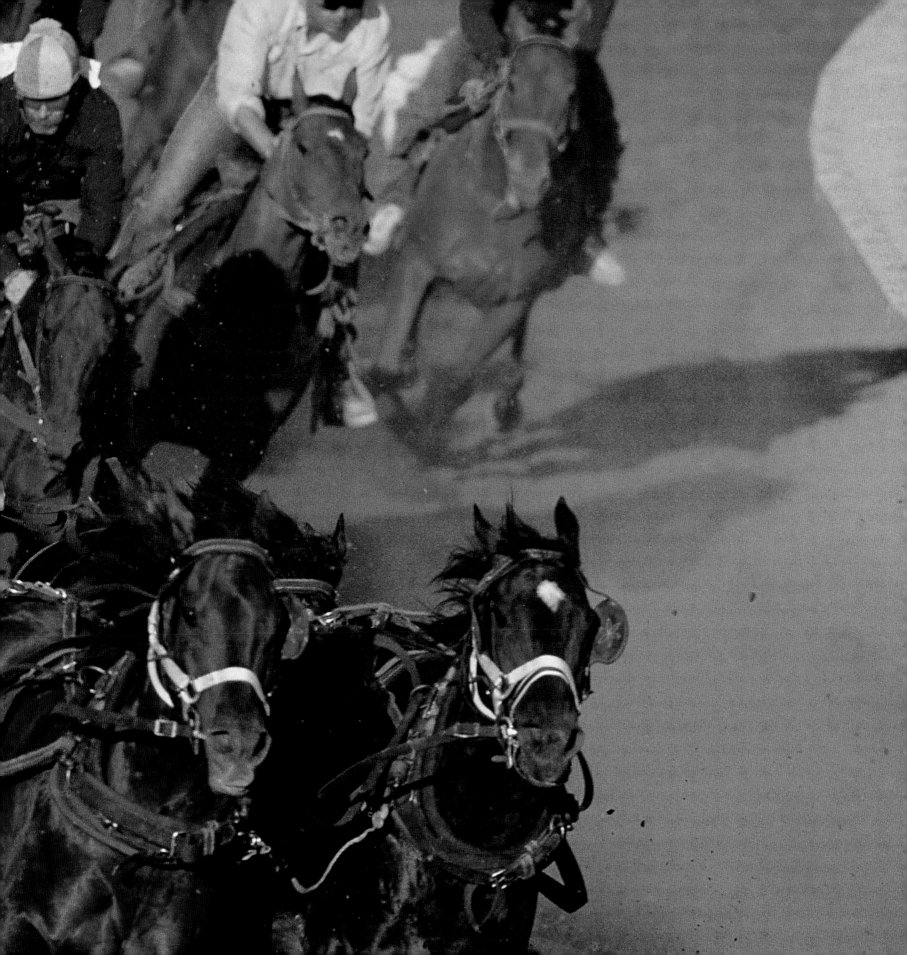

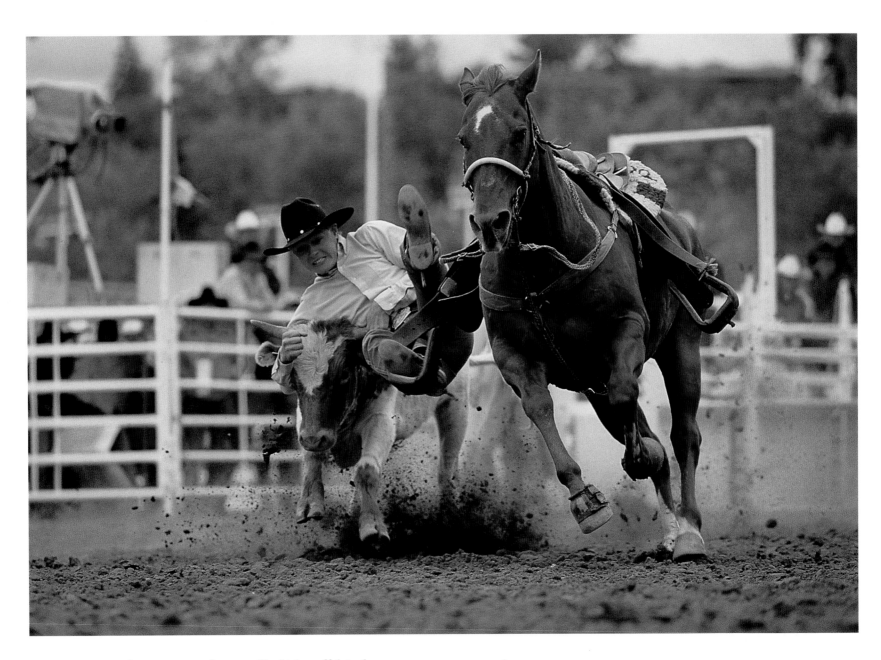

In steer wrestling, a cowboy will slide off his horse, grasp a steer's horns, and wrestle the animal to the ground, sometimes in under four seconds. The winners of major events such as this one can take home $50,000 in prize money.

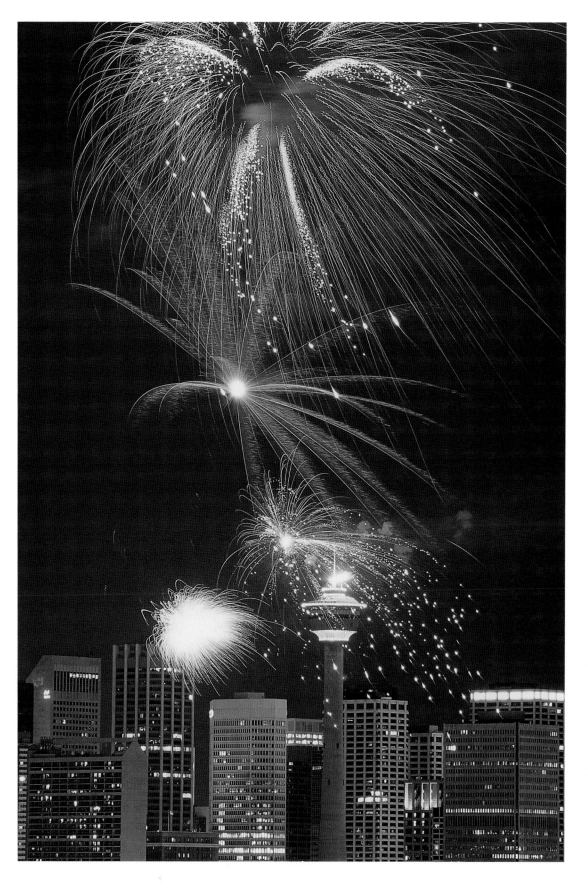

The tradition of the Stampede began in 1912, when Guy Weadick raised money among local business owners and staged "The Last and Best Great West Frontier Days." Up to 40,000 people flocked to each day's rodeo events, and even more watched the parade.

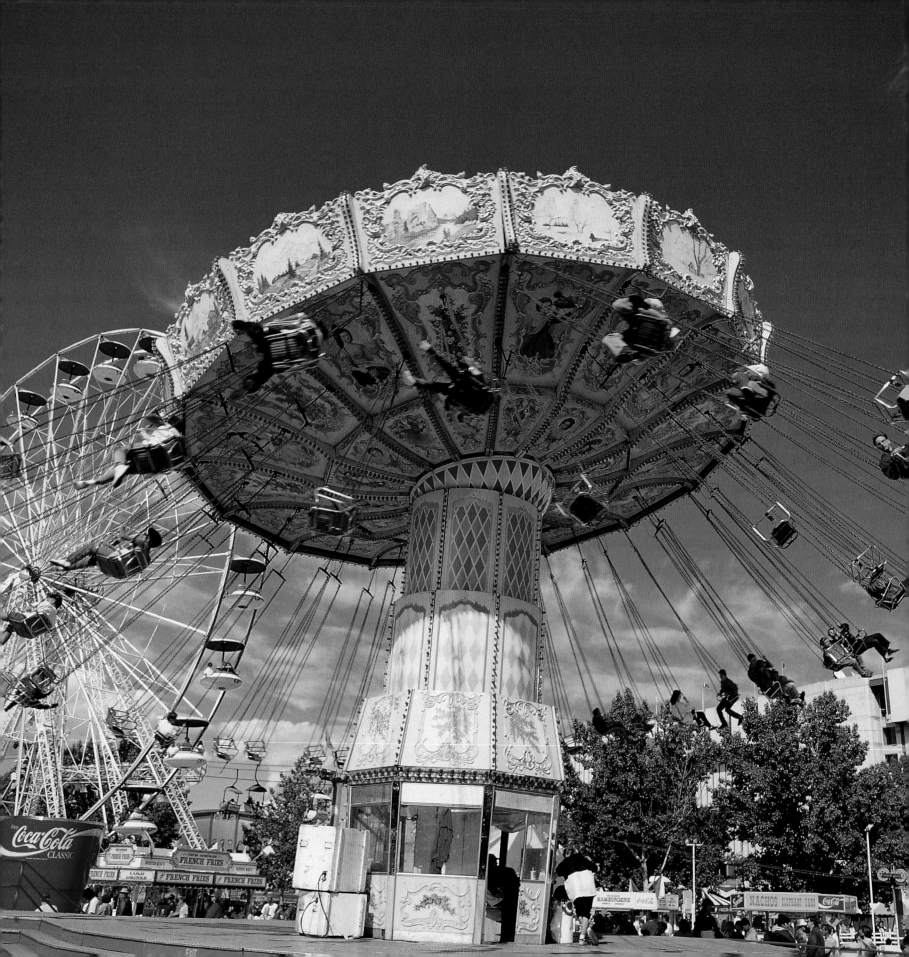

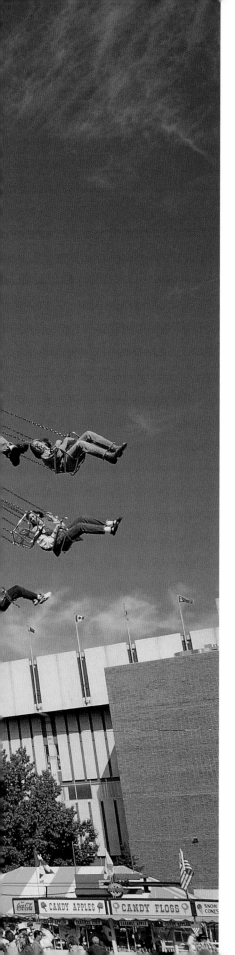

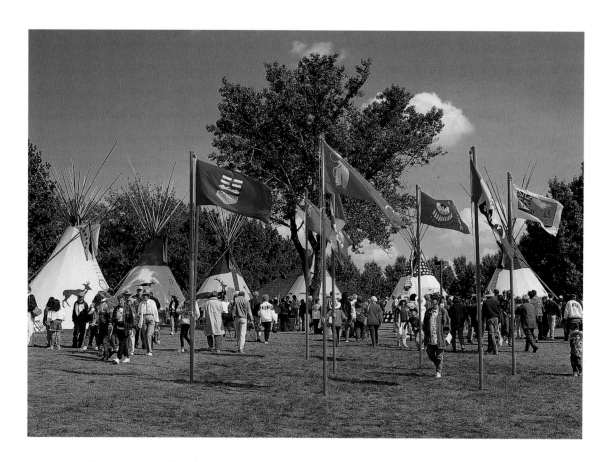

During the Stampede, local native families erect a teepee village and live for the week as their ancestors did centuries ago. The village includes representatives from each First Nation in southern Alberta.

Total profits from the Calgary Stampede can reach $45 million a year. The event requires the dedication of more than 200 permanent staff, 1,300 part-time staff, and 1,700 volunteers.

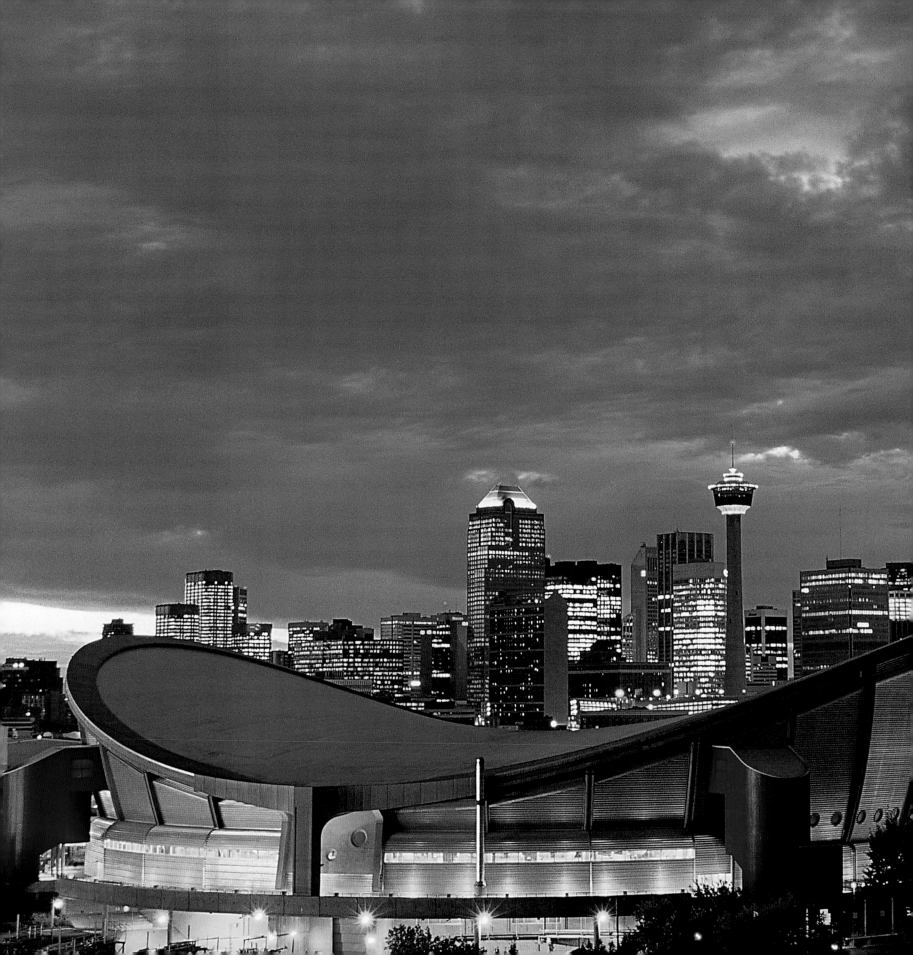

Built for the 1988 Winter Olympics, the Saddledome was designed to replicate the curve of a saddle. The 18,000-seat facility boasts the world's largest cable-suspended concrete roof and is home to the Calgary Flames hockey team.

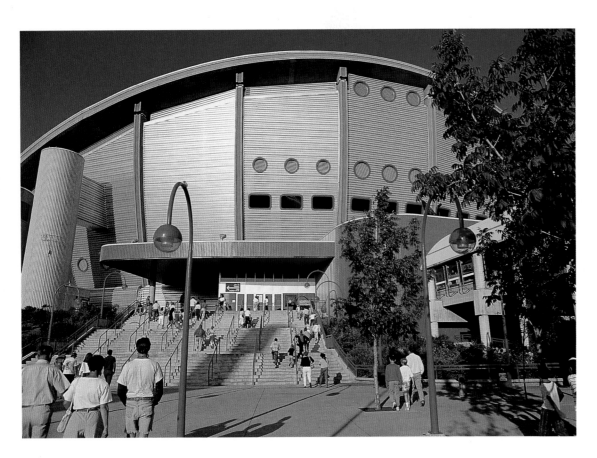

On any given day, the Saddledome may host an NHL hockey game, a rock concert, a trade show, or a rally. More luxury seats and a new scoreboard have recently been added to improve the facility.

For over two decades a balloonists club has thrived in Calgary, and members can be seen floating above skyscrapers on summer days. Balloon races are also part of the Calgary Stampede each year.

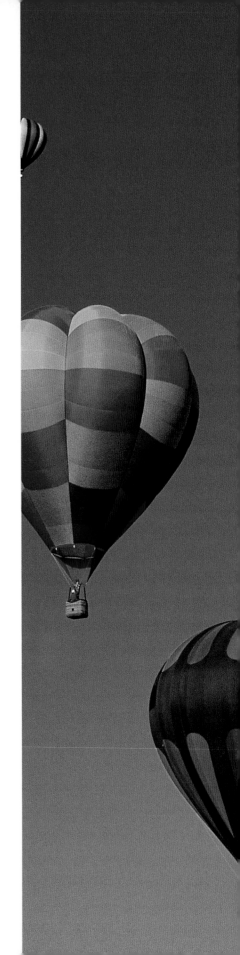

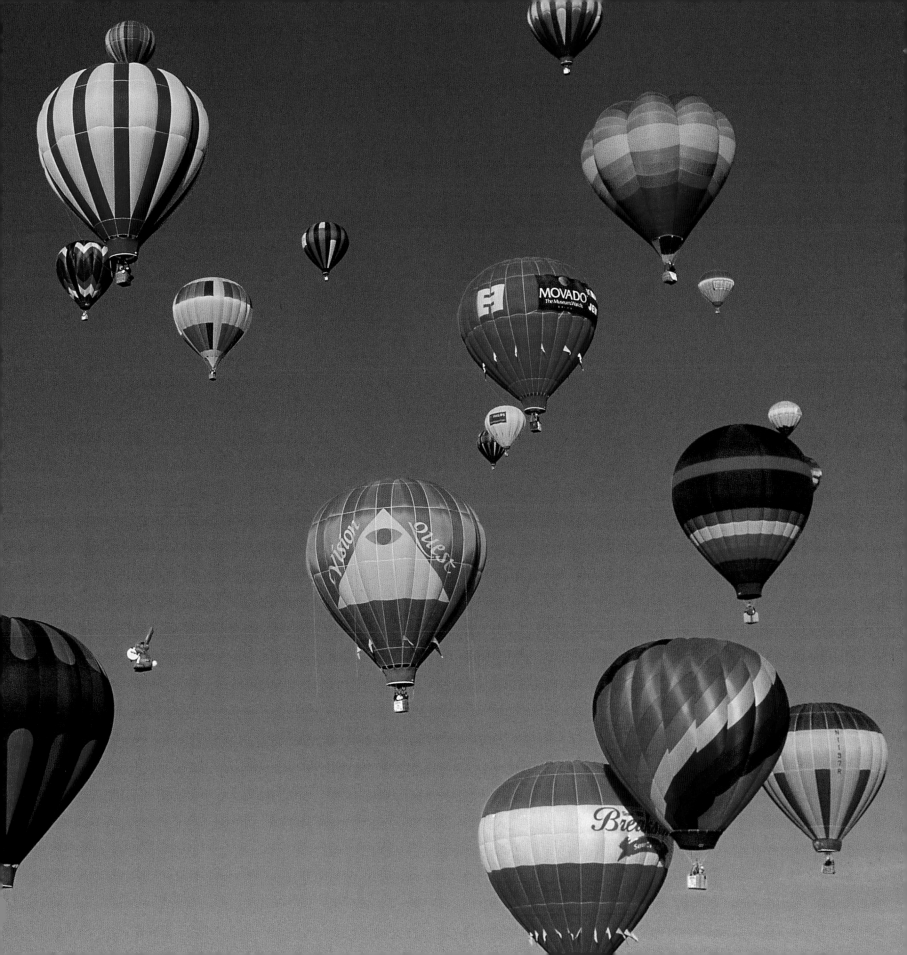

Canada's largest urban park, Fish Creek Provincial Park protects 1,170 hectares (2,900 acres) of aspen and spruce groves, grasslands, and floodplains. Archeologists have discovered prehistoric artifacts within the park and estimate that people first lived in this valley about 8,000 years ago.

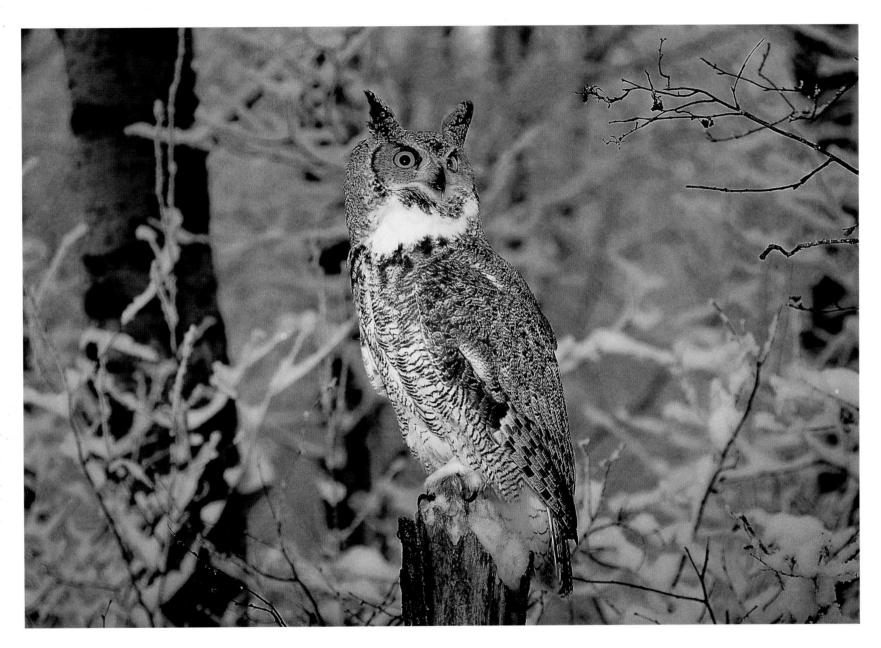

A great horned owl hunts mice and other small birds and animals in Fish Creek Park. This is the largest of Alberta's owls. It can grow to 65 centimetres (25 inches) tall and have a wingspan of 150 centimetres (60 inches).

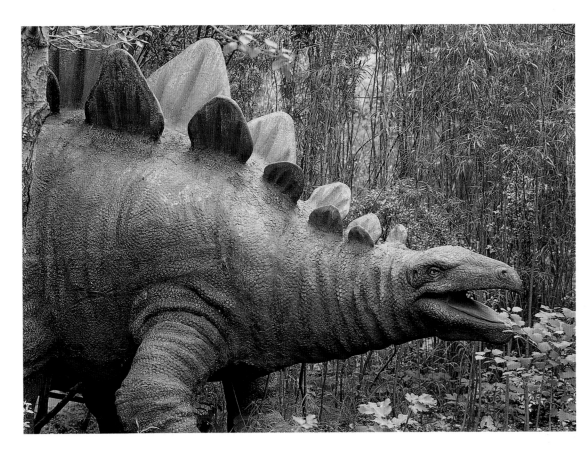

Twenty-seven full-sized dinosaur replicas at the Prehistoric Park stand among plants and rock formations similar to those that may have existed in southern Alberta eons ago.

The Calgary Zoo, Botanical Garden and Prehistoric Park is home to more than 10,000 plant and tree varieties and 1,200 animals from warthogs to gorillas. It is one of Calgary's most popular attractions, drawing 850,000 visitors each year.

The zoo is renowned for its re-creations of animal habitat and its educational programs. Preschoolers learn about nature through puppet shows and songs, older children meet zoo operators to learn animal facts, and adults meet to discuss conservation issues.

64

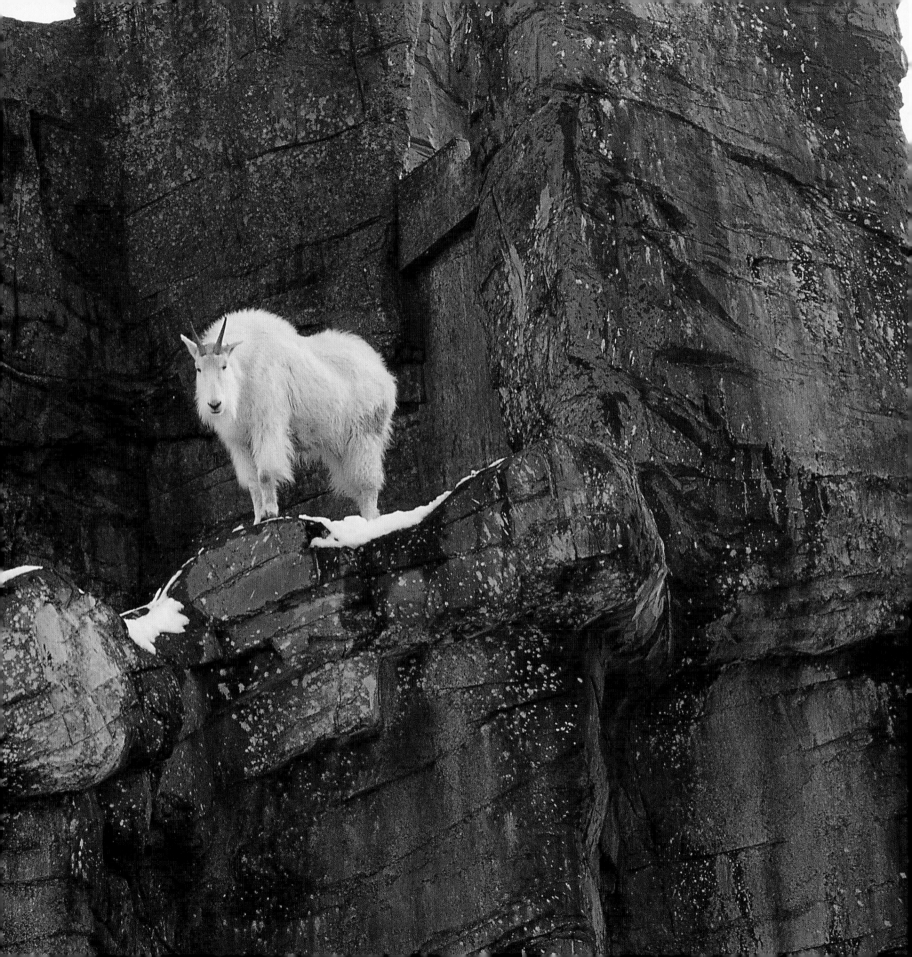

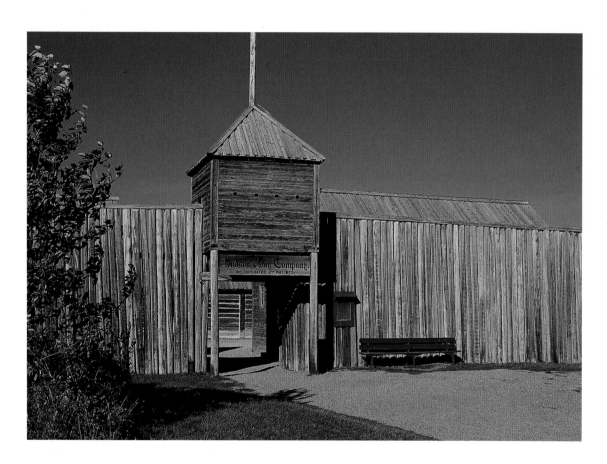

In 1875, the North West Mounted Police were dispatched from Ottawa to stop whiskey trading to First Nations and bring order to the West. They began the construction of Fort Calgary at the confluence of the Bow and Elbow rivers.

The *Moyie* cruises Glenmore Reservoir near Heritage Park, a tribute to the sternwheelers that once plied the rivers and lakes of Alberta and B.C.

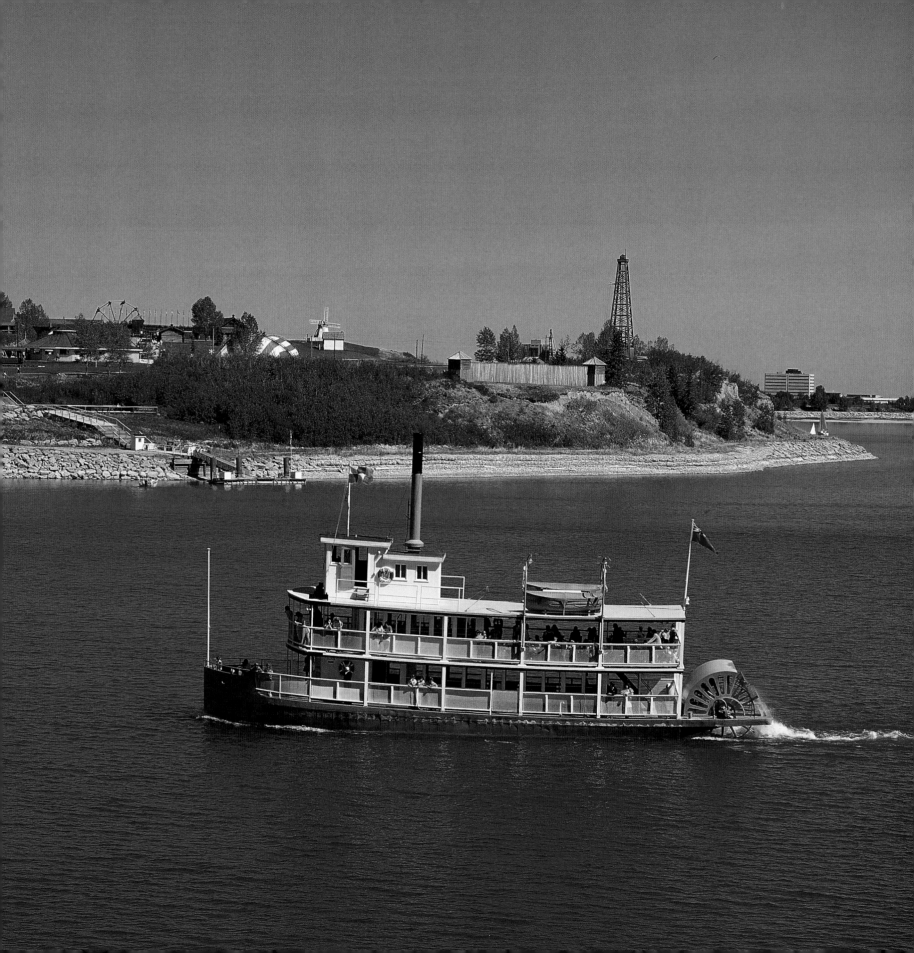

This 1920s windmill
once stood near
Bruderheim, Alberta,
but now graces the
water's edge at Heritage
Park. Eric Harvie, the
philanthropist whose
collections led to the
creation of the Glenbow
Museum, also played
a major role in the
development of this
historic site.

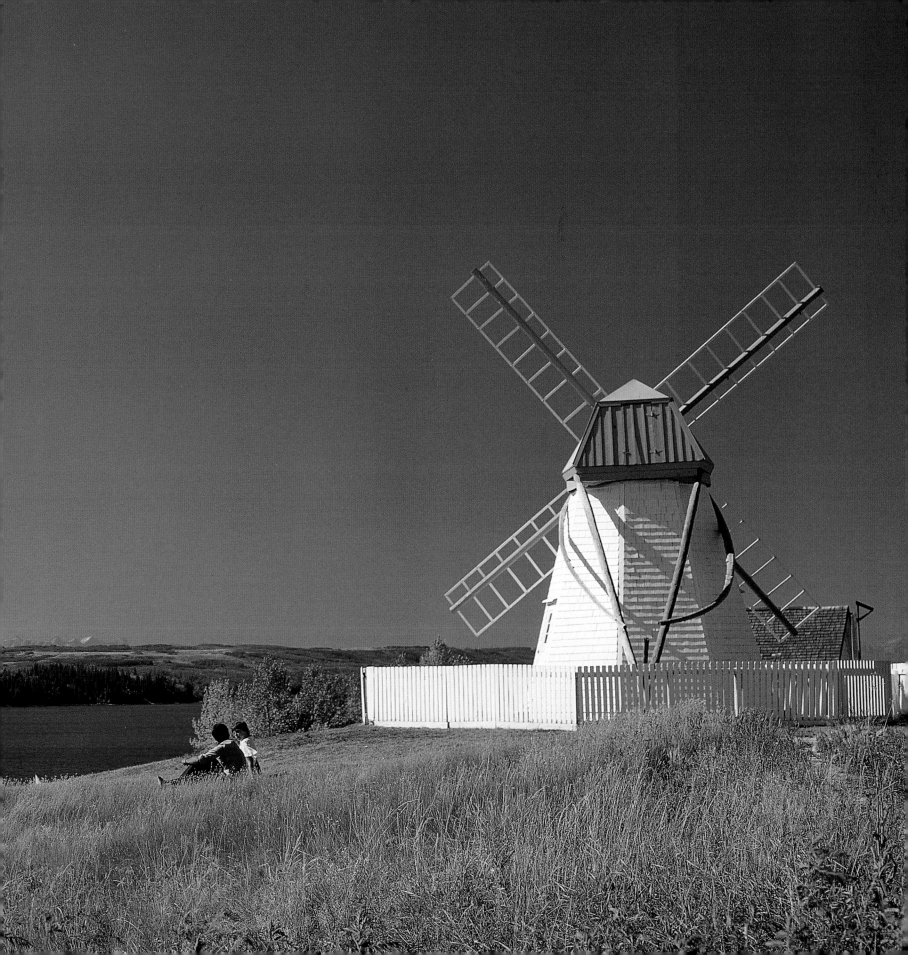

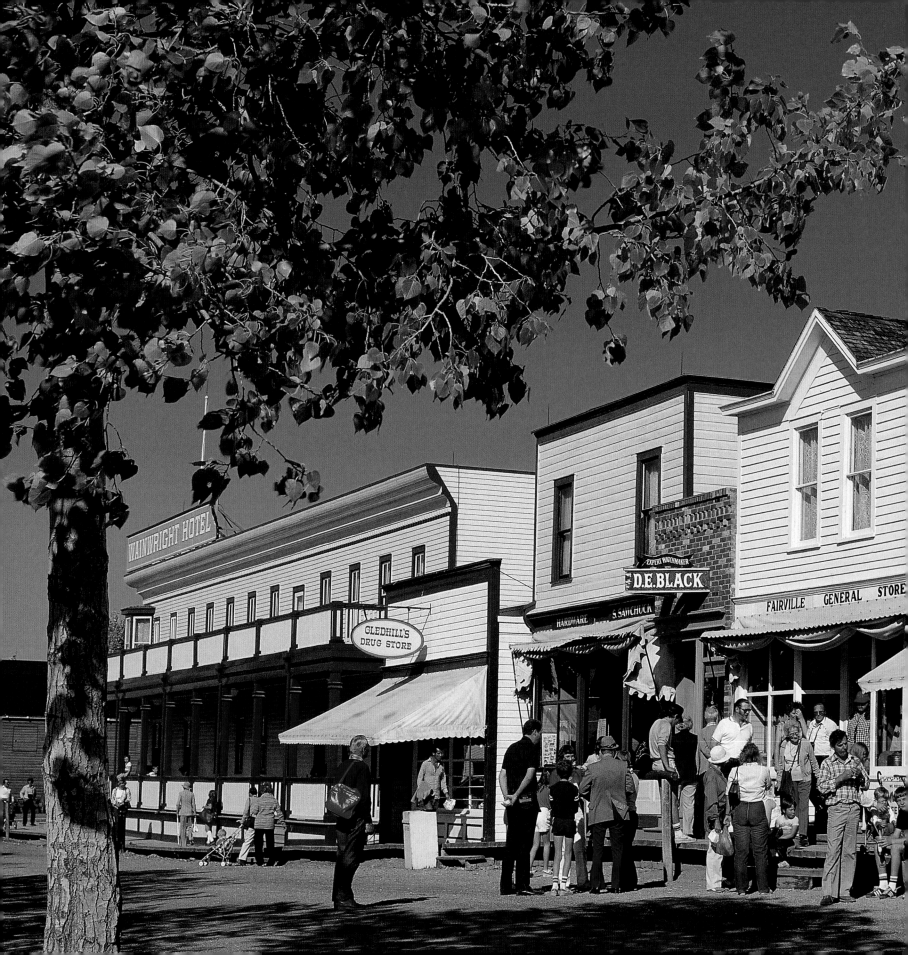

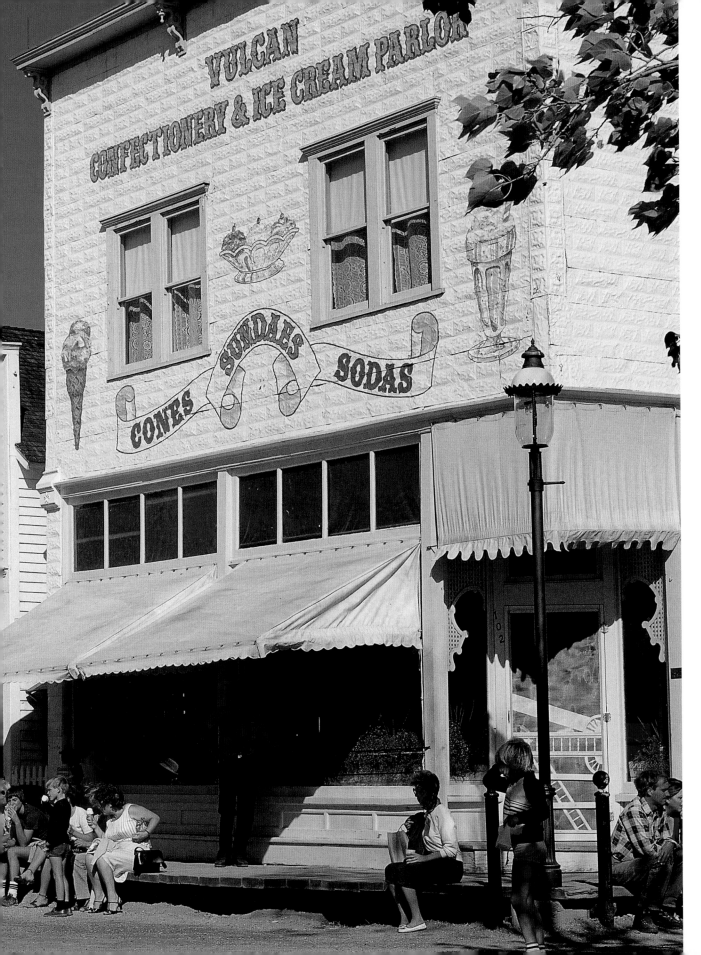

More than 70 original buildings and 30 re-creations bring turn-of-the-century days to life at Heritage Park. Attractions—from a log opera house and a blacksmith's shop to authentic residences and an antique streetcar—draw more than 25,000 visitors each year, making this one of the most popular heritage parks in the country.

71

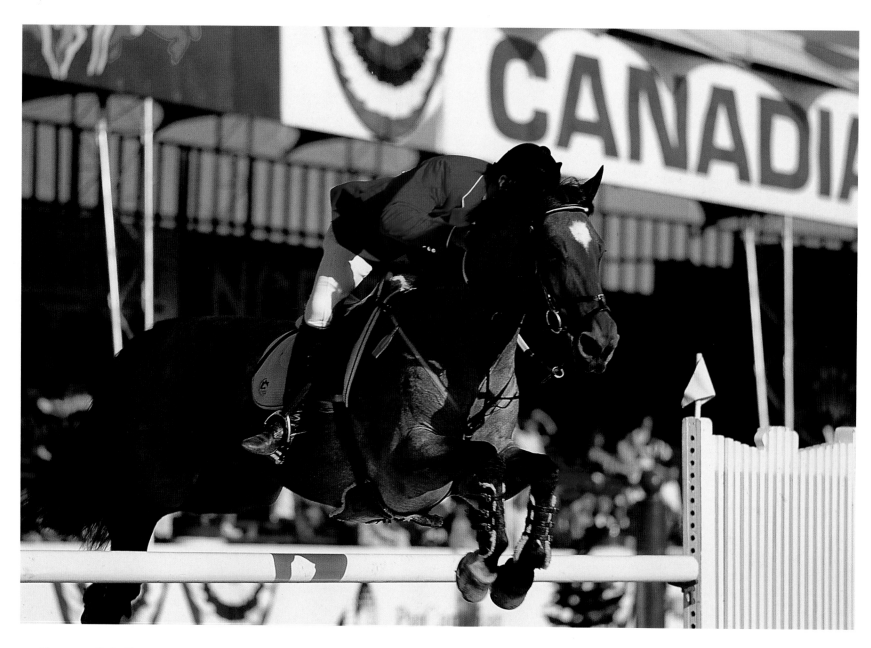

Millions of dollars in prize money are awarded at Spruce Meadows each year, as the world's top equestrians compete in internationally televised events, including the Masters.

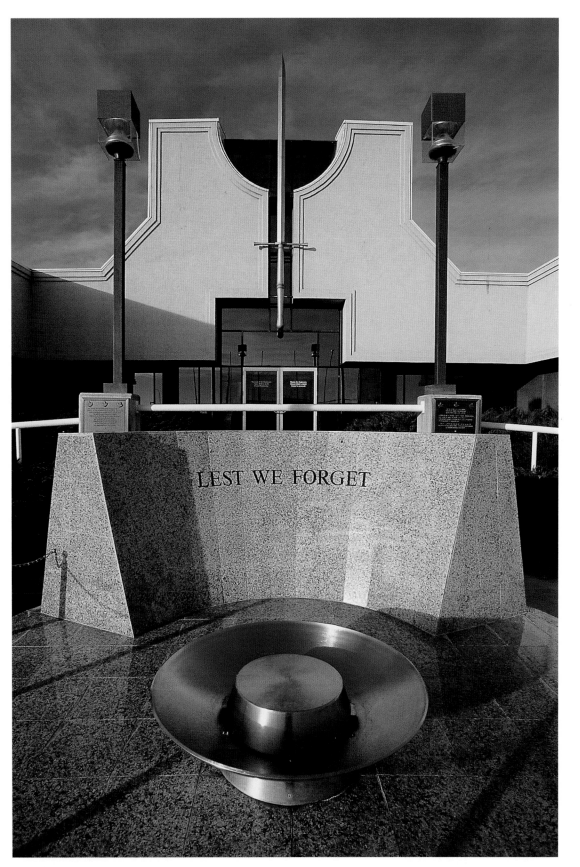

The Museum of the Regiments, opened by Queen Elizabeth in 1990, pays tribute to four regiments in which Calgarians served—Lord Strathcona's Horse Regiment, Princess Patricia's Canadian Light Infantry, the King's Own Calgary Regiment, and the Calgary Highlanders.

73

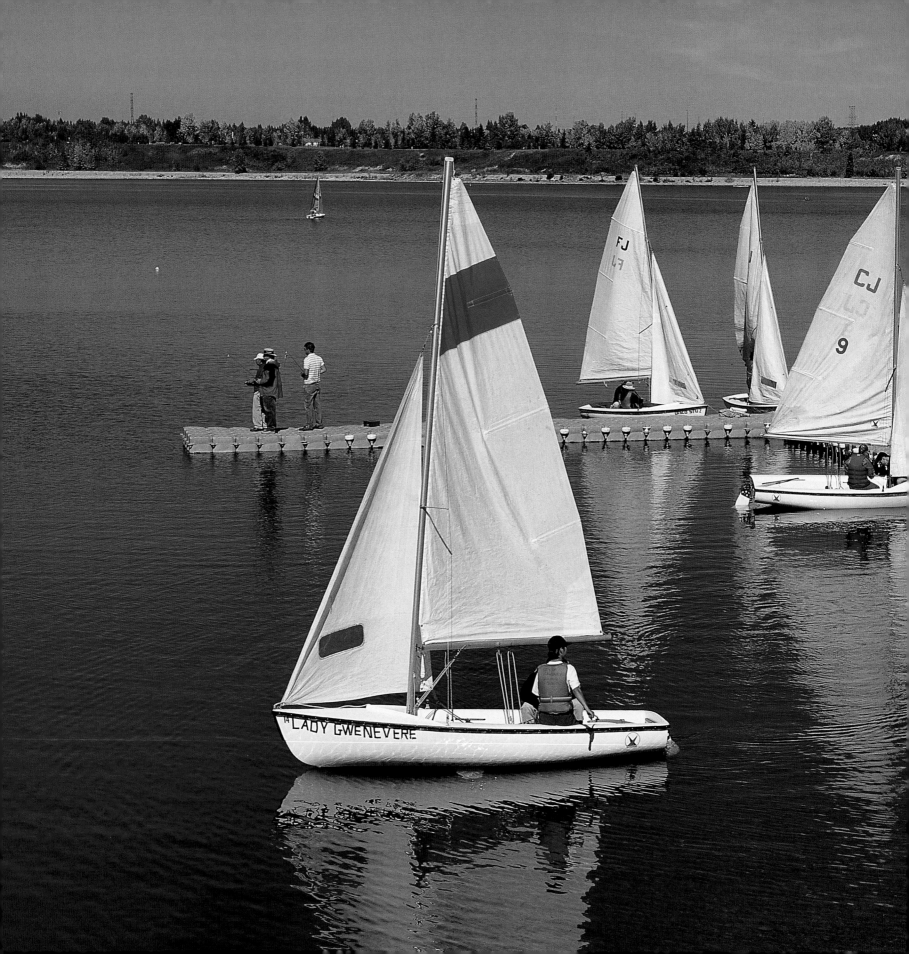

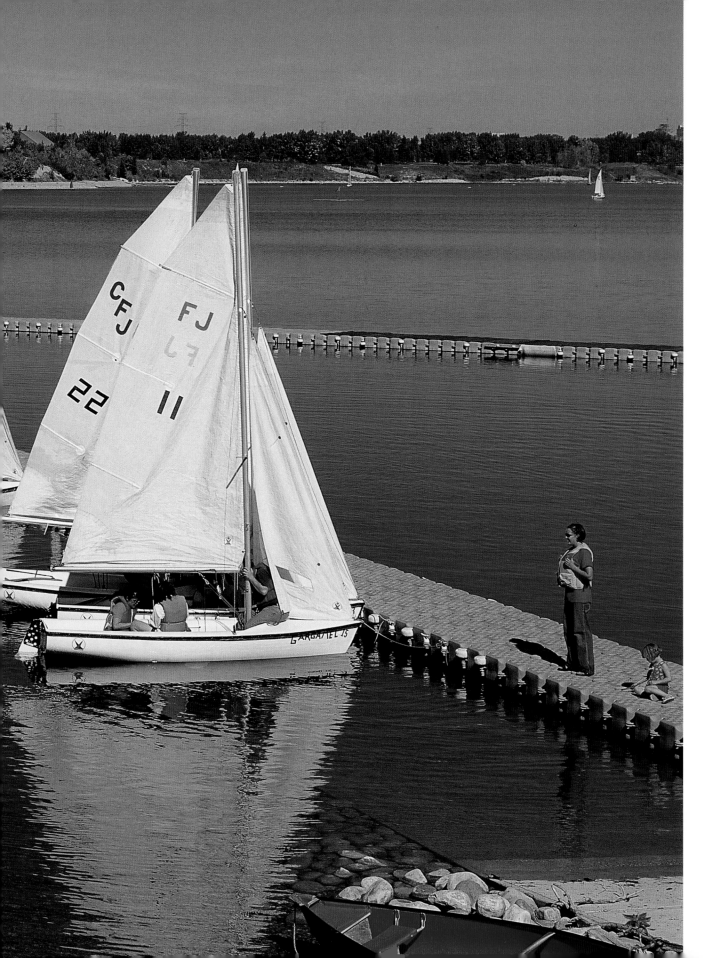

The Glenmore
Reservoir is created
by a dam on the
Elbow River.
Surrounded by pic-
turesque Glenmore
Park, the lake pro-
vides water for
southern Calgary and
a haven for sailors,
kayakers, and
canoeists.

Unique boutiques
and coffee shops
draw students from
the nearby Alberta
College of Art and
lend Kensington
a cosmopolitan
atmosphere.

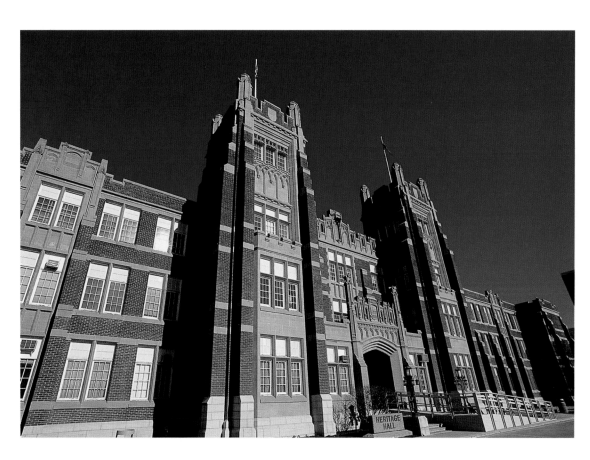

Heritage Hall at the Southern Alberta Institute of Technology was built between 1921 and 1922. Architect R.P. Blakely designed a number of public buildings in the early half of the century.

About 22,000 students attend the University of Calgary, studying in 16 faculties with more than 60 academic departments. With a yearly budget of $64 million, it's one of the top 10 research institutes in Canada.

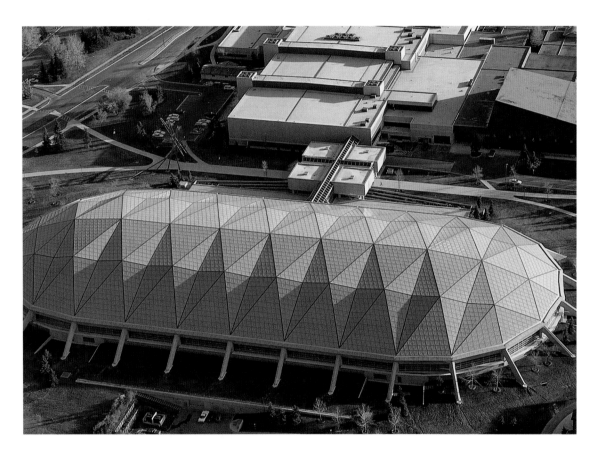

Olympic Oval at the University of Calgary was the site of the speed-skating competitions during the 1988 Winter Olympics.

Riley Park combines beautifully landscaped flower beds with open areas perfect for picnicking or sports. In the summer, free concerts are held in the park each Sunday.

Built for the 1988 Winter Olympic Games, Canada Olympic Park encompasses 95 hectares (235 acres) and boasts skiing, snowboarding, and bobsledding facilities. Visitors can even see ski-jumping in the summer, when the facilities are adapted for training.

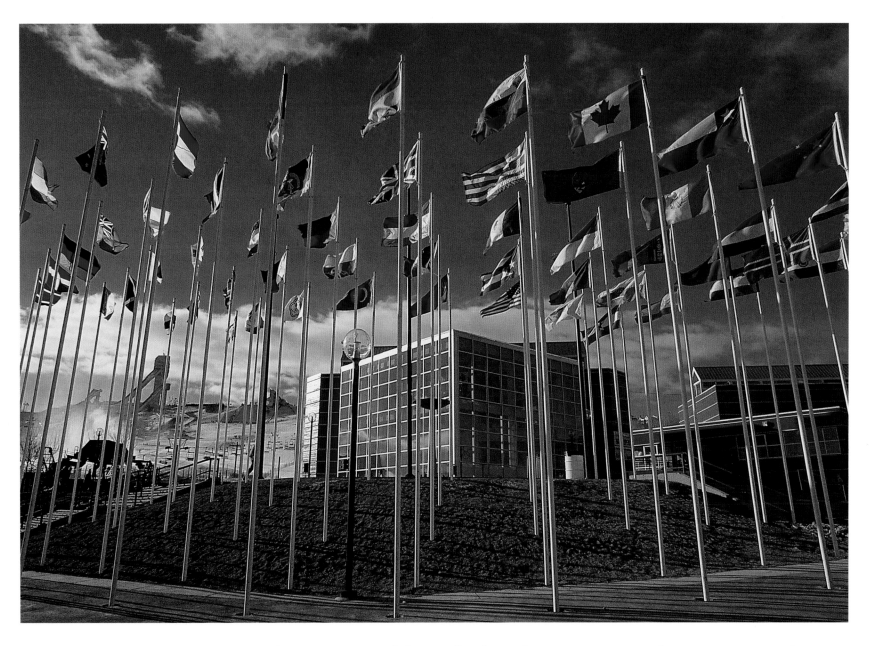

Some of the profits from the 1988 Winter Olympics were used to create an endowment fund. This fund helps to maintain the sports facilities built for the games, such as Canada Olympic Park. It also helps draw more world-class sports competitions to the city.

Calgarians spend their summers picnicking in Bowness Park, wandering the walkways, canoeing the lagoons, or enjoying miniature train rides, mini-golf, carnival rides, and playgrounds. In winter, the waterways become an expansive skating rink, free to the public.

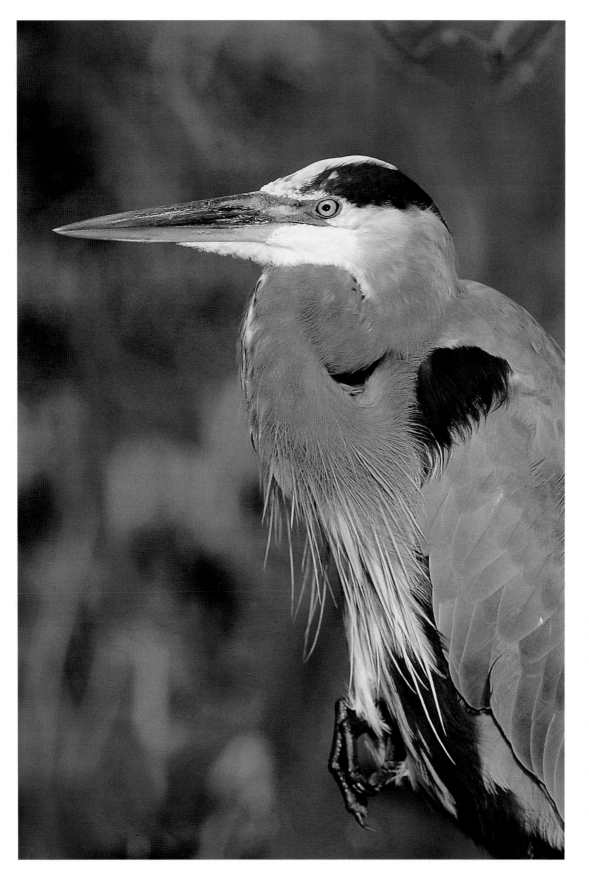

The wingspan of the great blue heron is equal to the armspan of a tall man. This majestic bird is most often spotted in the shallows of Alberta's wetlands, but it can also swim, plunging after prey in deeper water.

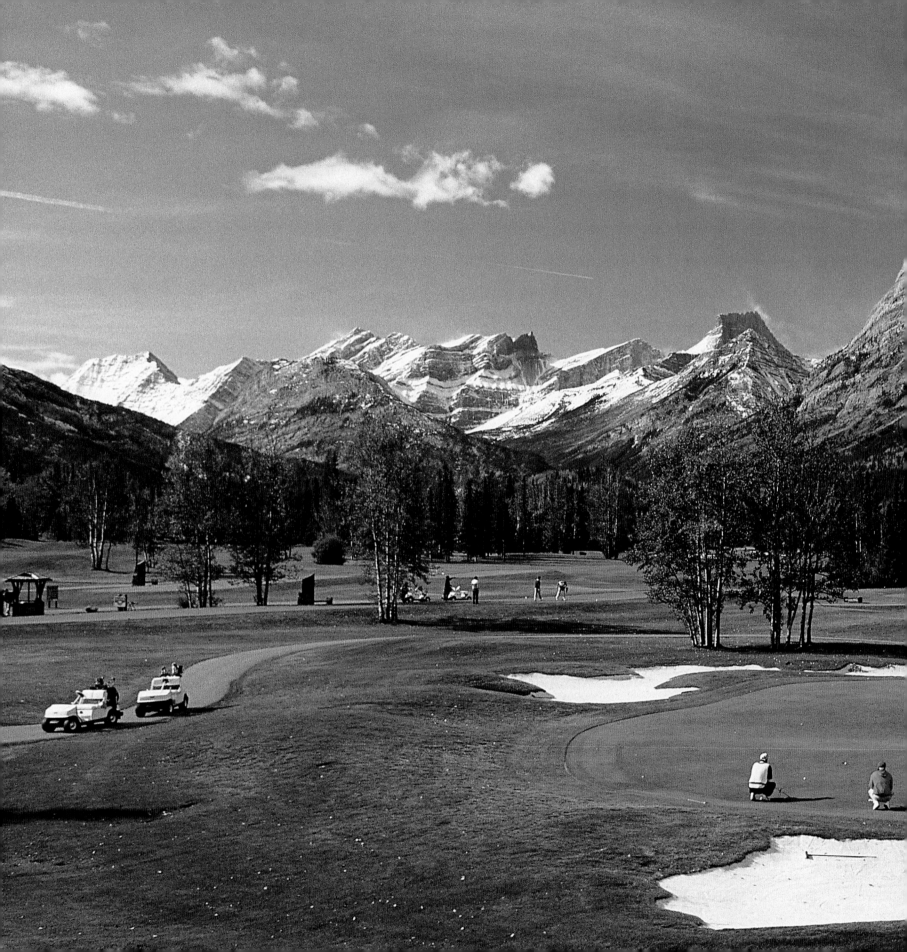

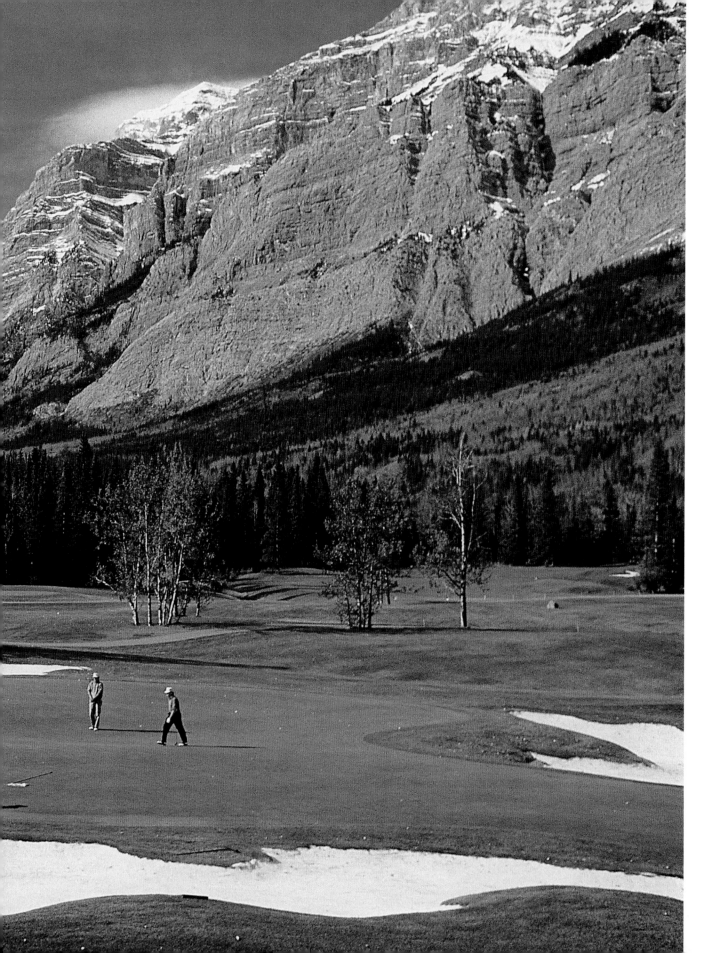

The Lorette and Kidd courses—one on each side of the Kananaskis River—comprise the renowned 36-hole Kananaskis Golf Course. Designed by Robert Trent Jones, the course was built by the province in 1983.

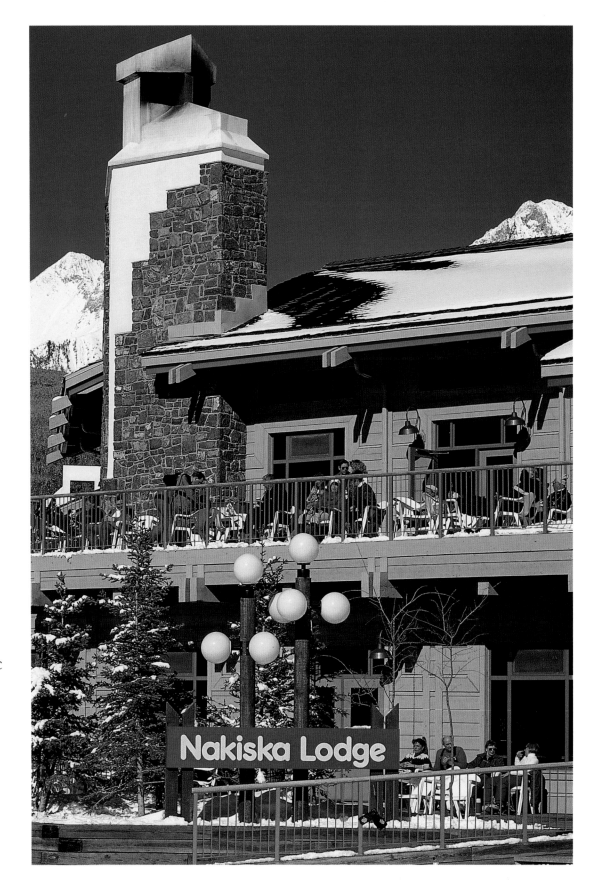

The Nakiska Ski Area was created for the 1988 Winter Olympics. Because warm Chinooks play havoc with snow conditions, the ski hill has state-of-the-art snow-making equipment, capable of creating snow from 24 million litres (6 million gallons) of water each day.

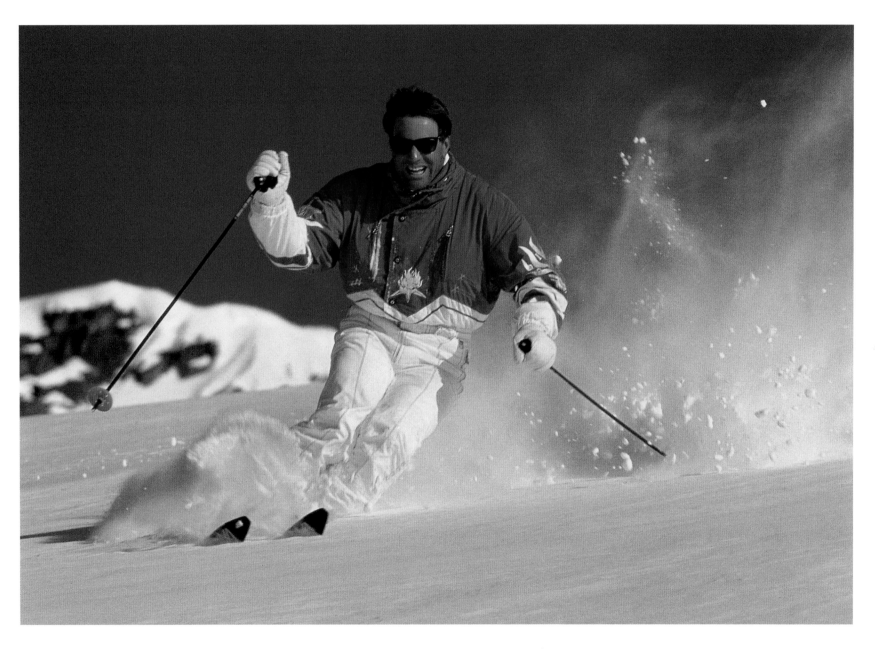

Nakiska Ski Area was specifically designed to appeal to all levels of skiers. About 70 percent of the runs are intermediate, and an additional 16 percent are designed for novices.

Kananaskis Country, a 4,250-square-kilometre (1,640-square-mile) recreation area, was created by the Alberta government in 1977. It encompasses Bragg Creek, Bow Valley, and Peter Lougheed provincial parks.

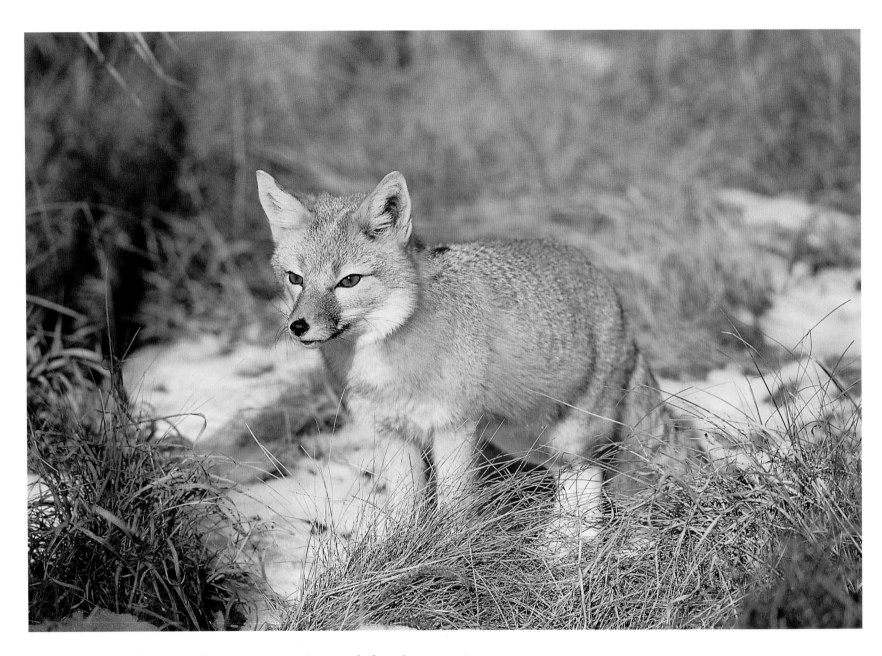

Though only the size of a house cat, the swift fox deserves its name
—it can reach speeds of 40 kilometres (25 miles) per hour. It lives
only in the grasslands of Alberta, Saskatchewan, and Manitoba, and
in the northern United States.

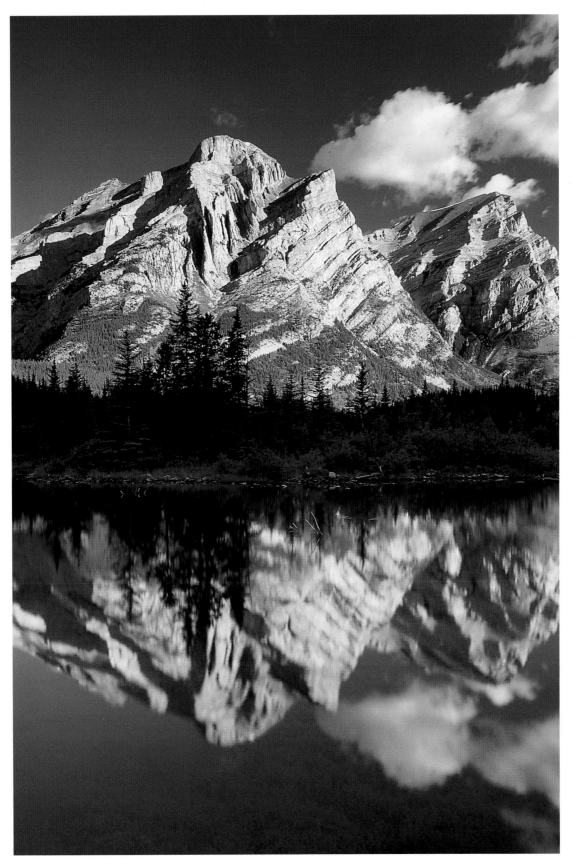

The mountains and valleys of Kananaskis Country are home to an amazing array of wildlife, including black and grizzly bears and one of the highest populations of cougars in the country. A variety of birds also populate the area, from songbirds to raptors such as eagles and hawks.

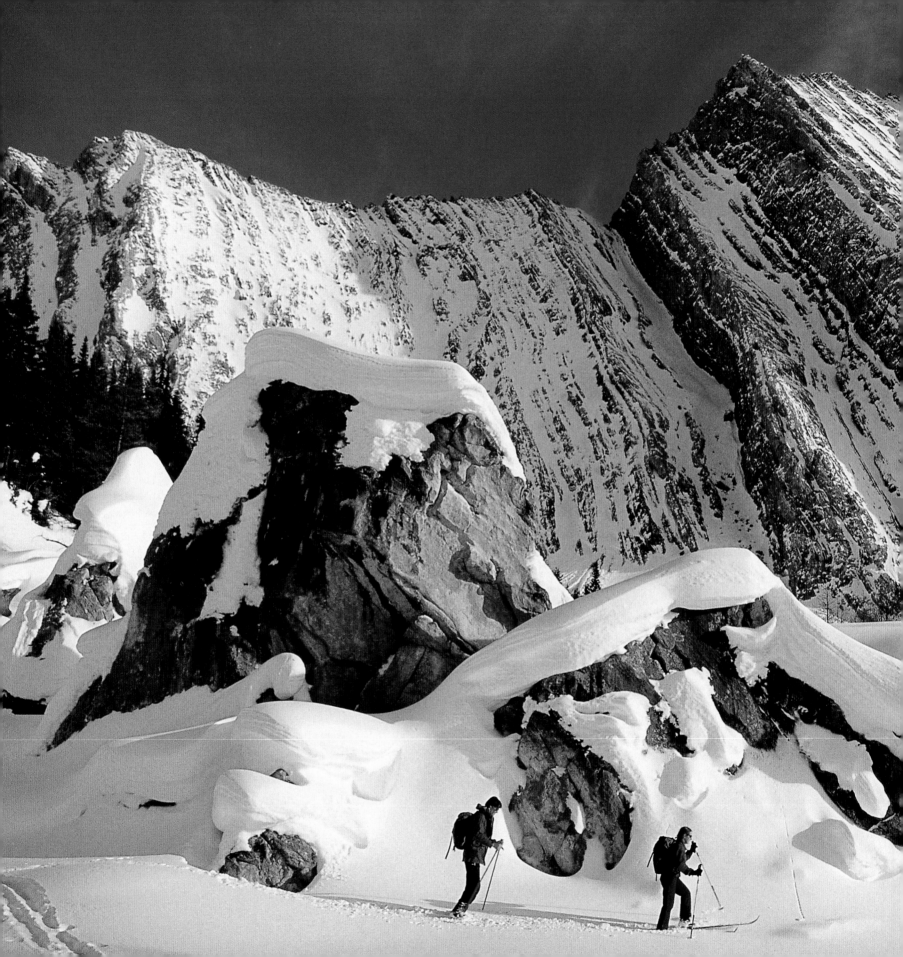

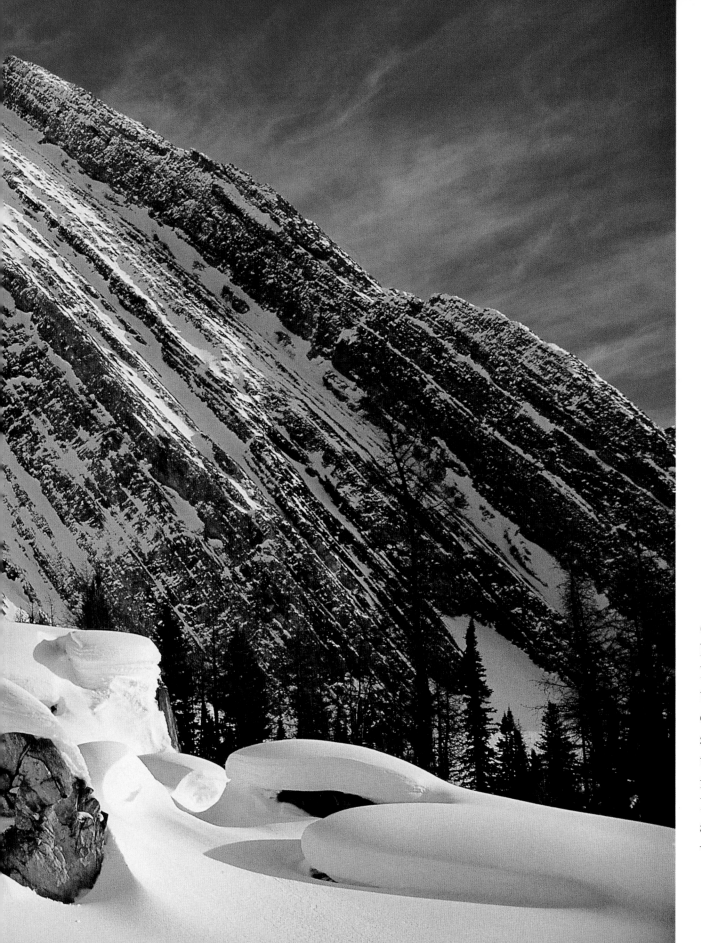

Captain John Palliser led the Palliser Expedition—a three-year trek of exploration and scientific study—through this region in 1858. He named Kananaskis Pass after a legendary native warrior.

Photo Credits

THOMAS KITCHIN/FIRST LIGHT i, iii, 24–25, 62

TONY MAXWELL/MACH 2 STOCK 6–7, 18–19, 40–41

TROY & MARY PARLEE 8

OLE TENOLD/MACH 2 STOCK 9, 22, 35, 36, 45, 46, 74–75, 84, 88

PETER SAUNDERS/MACH 2 STOCK 10–11, 34, 42–43, 73, 76–77, 79

ALAN MARSH/FIRST LIGHT 12

RON WATTS/FIRST LIGHT 13, 14, 23, 33, 56–57, 80

JOHN SUTTON 15, 16–17, 26–27, 31, 32, 54, 55, 63, 66, 67, 68–69, 70–71, 78

PATRICK MORROW/FIRST LIGHT 20–21, 89, 94–95

LARRY J. MACDOUGAL/FIRST LIGHT 28, 44, 48–49, 50–51, 52, 86–87

BIX BURKHART/MACH 2 STOCK 29

BRIAN CALKINS/MACH 2 STOCK 30

RON KELLY/MACH 2 STOCK 37

BAIBA MORROW/FIRST LIGHT 38–39

W. MORGAN/FIRST LIGHT 47

MICHAEL SROKA/MACH 2 STOCK 53

ALAN SIRULNIKOFF/FIRST LIGHT 58

HARRY JORDAN/MACH 2 STOCK 59

WAYNE LYNCH 60, 61, 85, 92

HELGA PATTISON/MACH 2 STOCK 64–65, 72, 82, 83

JAMES BURTON/MACH 2 STOCK 81

DARWIN WIGGETT 90–91

DARWIN WIGGETT/FIRST LIGHT 93